D1394096

DUBLIN

Donated to

**Visual Art Degree
Sherkin Island**

738

8/2292436

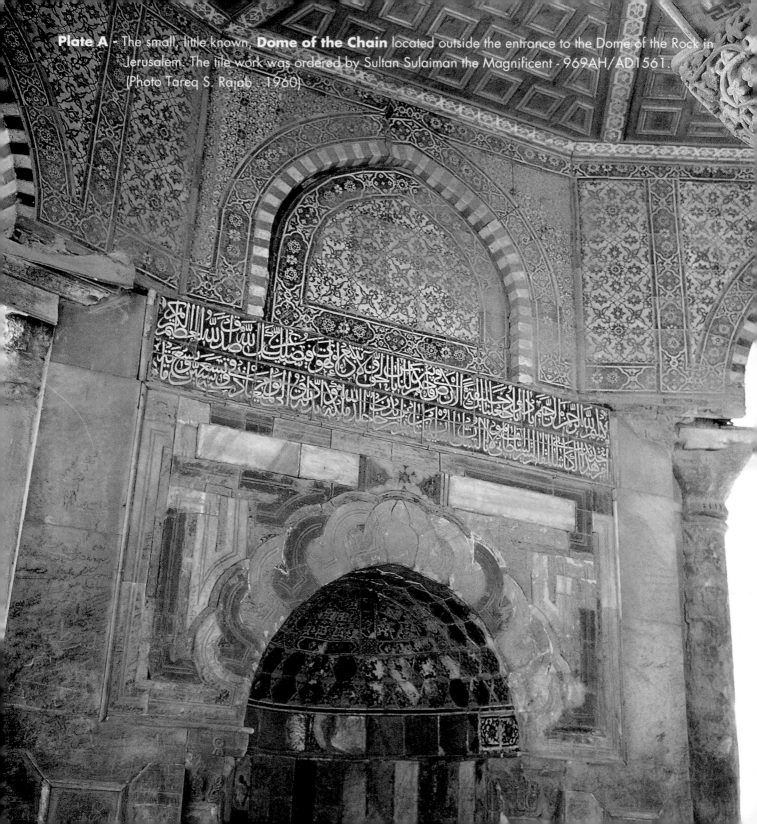

Plate A - The small, little known, **Dome of the Chain** located outside the entrance to the Dome of the Rock in Jerusalem. The tile work was ordered by Sultan Sulaiman the Magnificent - 969AH/AD1561. (Photo Tareq S. Rajab - 1960)

POTTERY OF
THE ISLAMIC WORLD
IN THE TAREQ RAJAB MUSEUM

Géza Fehérvári

TAREQ RAJAB MUSEUM
KUWAIT

Published by:
Tareq Rajab Museum,
P.O.Box 6156,
32036-Hawally,
KUWAIT.

© 1998 Tareq Rajab Museum, Kuwait.
All rights reserved. No part of this book may be reproduced or utilized in any form or by any means, electronic or mechanical, including photocopying, recording or by any information storage and retrieval system, without prior permission of the copyright holder.

Email : trm@kuwait.net
Homepage : www.kuwait.net/~trm/index.html

Typesetting by Mohammad Safdar

All photographs are by Stephanie McGehee except those indicated.

Designed and prepared by the Tareq Rajab Museum, Kuwait.

ISBN Paperback: 1 86064 364 7
 Hardback: 1 86064 363 9

Printed in the State of Kuwait.

CONTENTS

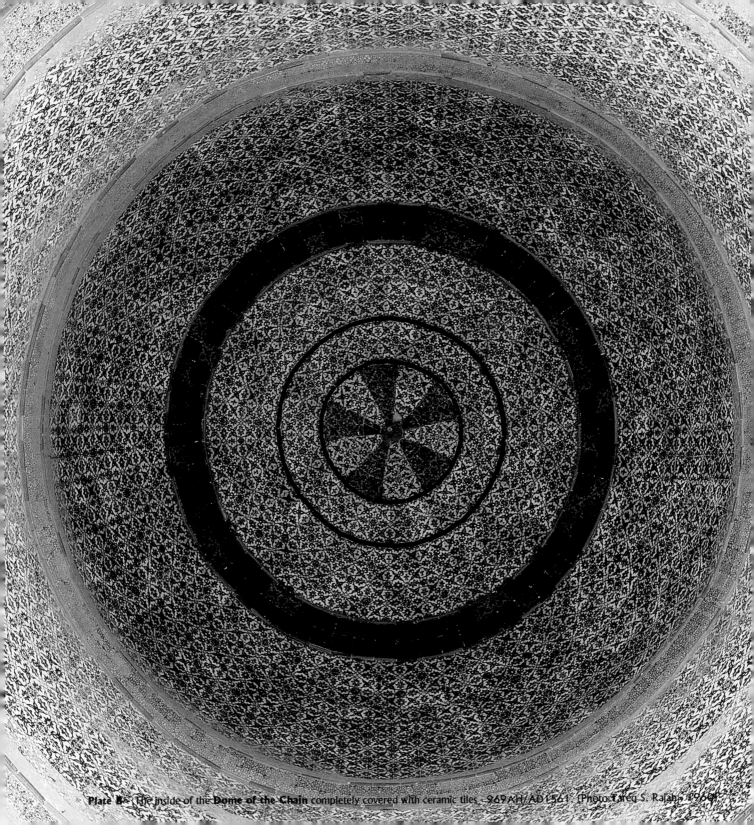

Plate 8 The inside of the **Dome of the Chain** completely covered with ceramic tiles - 969 AH/AD 1561. (Photo: Tareq S. Rajab, 1966)

Introduction

The pottery collection of the Tareq Rajab Museum is extremely rich and comprehensive. Not only the Islamic, but pre-Islamic pottery is also well represented. This small handbook can present only samples of this extremely fine and important collection. The items were selected in a way that they introduce every periods and types, so that the development of ceramics in the Islamic world could easily be followed. The material is divided into ten parts. The last one deals with unglazed wares, pottery moulds and introduces a unique piece, a small underglaze-painted pottery figurine, the self-portrait of a one-armed potter.

Géza Fehérvári
Tareq Rajab Museum
Kuwait
March, 1997

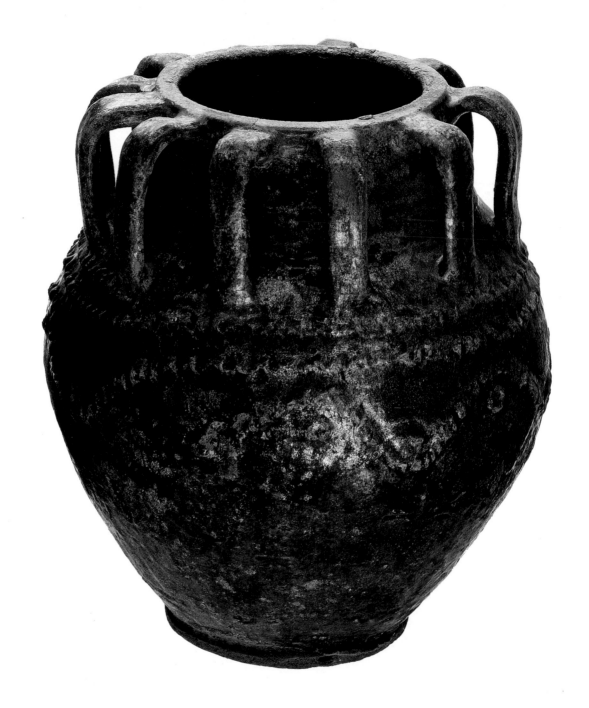

1.	**Large Jar**, faience body, covered with a turquoise-blue alkaline glaze, with *appliqué* decoration.
	Iran or Iraq, 7th - 8th century AD.

1. PRE AND EARLY ISLAMIC PERIODS

Pottery production in the Near and Middle East reached a very high standard both in techniques and decorative styles long before the advent of Islam. Faience, which played such an important role in the history of Islamic pottery, was invented and introduced in Egypt as early as the 4th millennium BC. This "Egyptian faience" had a yellowish paste and was covered with a brilliant bluish alkaline glaze. Later it appeared in Syria, Mesopotamia and Persia during the Parthian (2nd century BC - early 3rd century AD) and Sasanian periods (226 - 651AD) and continued to be produced right up to early Islamic times. Shapes, pastes and colour of the glaze or even the decoration hardly changed for centuries. One of the most typical vessels of this type of pottery were large jars. They are known as **Sasano-Islamic, or green and blue wares**. A large jar of this type in the Tareq Rajab

Museum is covered with a turquoise-blue, now highly iridescent glaze (**no. 1**). On its upper part, it has eleven handles and is decorated with a serpent coiling around and small round discs in *appliqué*. It may be dated to the period between the 7th and early 8th centuries. Another popular vessel of the late Sasanian and early Islamic period was the pilgrim flask. It was usually made of red or white earthenware of two halves in identical moulds and fixed together. The moulded decoration frequently depicts a solar pattern in the centre from which rays are radiating. The Tareq Rajab Museum's specimen is coated with a green lead glaze (**no. 2**). A similarly decorated green glazed pilgrim flask was excavated at Tarsus in south-eastern Turkey and dated to the Umayyad period (661 - 750 AD).

3333301035617.74/738 · 32917

2. EARLY ABBASID PERIOD

The Umayyads were overthrown by the Abbasids in 132AH/AD750, who then moved their capital to the newly established city of Baghdad. Hardly a century later, in 221AH/AD836 a new capital, Samarra was built on the banks of the Tigris, some 100km north of Baghdad. The court stayed there for only 47 years, then they moved back to Baghdad. The walls of palaces, mosques and even private houses were decorated with stucco carvings, frescoes and tilework. Among the ruins thousands of early Islamic pieces of pottery were excavated. These early types of ceramics included the so-called **lead-glazed relief ware**, which owed its origin to the identical Roman pottery. They were made of earthenware, with moulded decoration, imitating the designs of contemporary metal vessels, then were coated with a green or brownish-yellow lead glaze. A lead-glazed relief bowl in the Museum has a large Y-shaped band decorated with pearl motifs, which divide the surface into three equal parts decorated with leaves and clusters of dots (**no. 3**). This bowl may have been made in Syria or Iraq during the late 8th or early 9th century AD.

Another early type of pottery was the so-called "splashed ware". The surface of the vessels was decorated with splashes of green, brown and yellow under a transparent lead glaze. The production of this ware may have been influenced by the closely related Chinese T'ang period polychrome ware. The Tareq Rajab Museum has a number of interesting splashed ware. One example is a boat-shaped lamp supported by a cylindrical shaft which in turn is placed in a circular tray and has a straight handle (**no. 4**). A very similar lamp was excavated at Nishapur in north-eastern Iran and dated to the 9th and 10th centuries.

The Samarra finds also included the so-called "opaque white" or "tin-glazed" earthenware, imitating

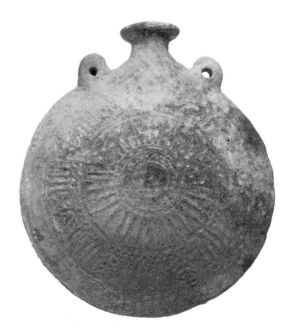

2. **Pilgrim flask**, monochrome glazed, Umayyad, buff earthenware, coated with a dark green lead glaze and deocrated with a solar pattern and rays.
Probably Syria, Umayyad period, 7th - 8th century AD.

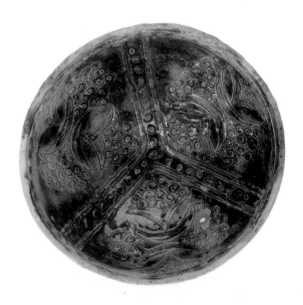

3. **Bowl**, lead-glazed relief ware.
Syria or Iraq, late 8th or early 9th century AD.

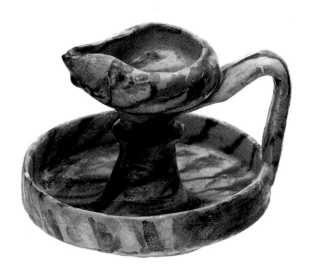

4. Pottery Lamp, splashed ware.
Iran, late.9th or 10th century AD.

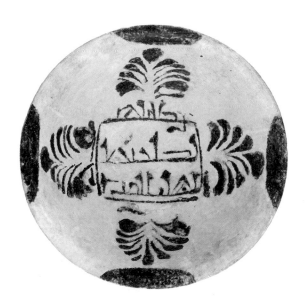

5. Bowl, opaque-white, or tin-glazed ware, with cobalt-blue decoration. The inscription reads: *"blessing to the owner, made by Ahmad".*
Iraq, probably Basra, 9th century AD.

contemporary Chinese white porcelain. The Iraqi examples were decorated with cobalt-blue designs and inscriptions painted over the opaque glaze. The Iranian vessels were painted in copper-green and sometimes with yellow designs and inscriptions. A large bowl in the Museum bears the signature of an artist called *Ahmad* (**no. 5**).

Lustre-painting, a special decorative technique, was already known and used by the Copts of Egypt from the 4th century AD onwards on glass. On pottery, it was applied for the first time during the second half of the 9th century. At the beginning, vessels and tiles were painted in polychrome. An early polychrome lustre bowl in the Tareq Rajab Museum is decorated with flowers, "eye" motifs and chevron patterns, painted in brown, yellow and some ruby red colours (**no. 6**).

By the second half of the 10th century, the decoration became monochrome and then it often included human figures, animals or birds, e.g. the figure depicted on a small bowl represents the portrait of a dancing lady (**no. 7**).

About the same time, i.e. during the late 9th - early 10th centuries, in north-eastern Iran and Central Asia a new type of pottery was developed, the so-called slip-painted ware. The ground slip, which covered the surface of the vessels, prevented the colour or colours from running under the transparent lead glaze, thus carefully painted epigraphic, floral or figural designs could be applied on these vessels. There are several types of slip-painted wares, including the Nishapur polychrome. A Nishapur polychrome ware in the Tareq Rajab Museum depicts a seated female figure approached by two angels (**no. 8**). This could be the survival of a Sasanian investiture scene.

Another variation of the slip-painted wares was when the decoration was painted in manganese-purple over

13

a white or creamy background. Most of them display epigraphic bands written in different types of the so-called Kufic, or angular script. There are a few outstanding examples, mainly large bowls presenting inscriptions combining simple, foliated, floriated and plaited Kufic styles. There is a large bowl of this type in the Museum (**no. 9**). The vessel is covered all over, including its base, with a white ground slip and the inscription is presented in a beautifully written floriated and plaited Kufic, reading: *"He, who believes in recompense is generous to the offer".* Apparently this was one of the favourite proverbs of the Prophet and Imam Ali.

The third type of slip-painted pottery was painted in polychrome on white ground slip. The colours used in addition to manganese-purple, included tomato-red, yellow and green. Manganese is mainly used for inscriptions or for outlining the major designs. There is a large bowl of this "polychrome-on-white" type in the Tareq Rajab Museum which is an outstanding example in many respects (**no. 10**). First of all, it successfully combines a long simple Kufic inscription with red and manganese decorated fields which occupy the empty spaces and secondly, because this is the only known example of this type of pottery with a date. Finally, the Kufic inscription, which makes two complete turns around the cavetto is a quotation from the Qur'an, *Surat al-Qalam*, verses 51-52. That makes it the earliest known pottery vessel with a Quranic inscription. The date is in the centre on the top, reading: *"thalathami'a", "three hundred",* which is equivalent to 912 AD.

An interesting group of the slip-painted pottery is known under the term of "yellow - staining - black" ware. They are distinguished from the black-on-white group by the yellowish colour of its glaze. According to their decoration, they may be divided into two sub-groups: first when the decoration is somewhat restricted, the designs are limited to the rim or to the upper part of the cavetto. They are mainly epigraphic, showing Kufic inscriptions on their own, or combined with dotted zones or scrollwork. If there is a decoration at the centre, then it is usually one word: *"al-baraka", "blessing",* or a stylised flying bird. The second sub-group presents naively drawn animals, birds, occasionally even human figures. There are nearly forty pieces of the "yellow-staining-black" type in the Museum, including both sub-groups. The large bowl illustrated here, belongs to the first sub-group (**no. 11**).

Detail from No. 6.

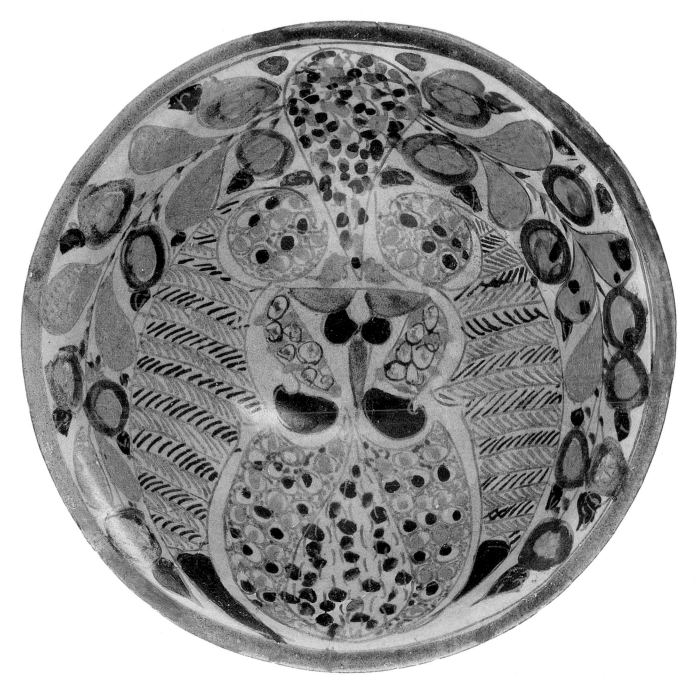

6. **Bowl**, painted in brownish-red, yellow and green lustre, depicting floral, slanting strokes and "eye"-motif decoration. *Iraq or Egypt, late 9th or early 10th century AD.*

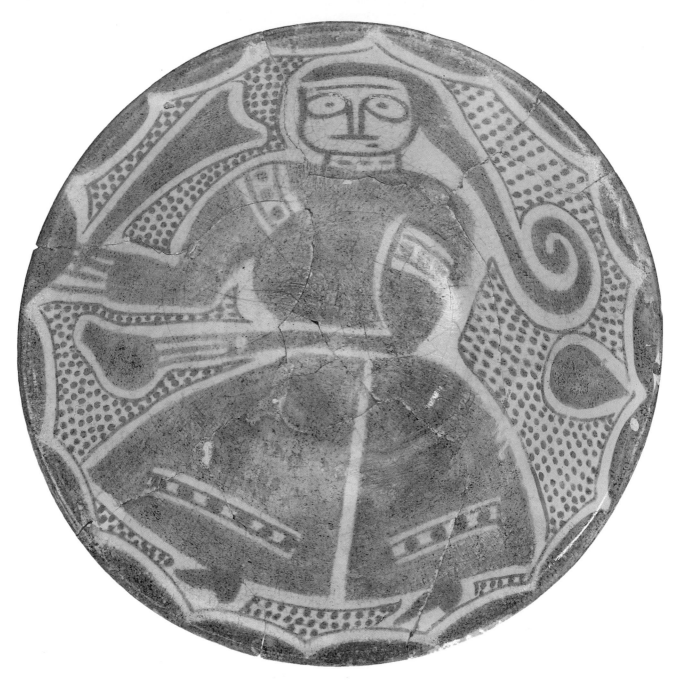

7. **Small bowl,** painted in yellowish-green monochrome lustre, showing the portrait of a dancing lady, holding a goblet in her right hand and a conical object, perhaps a bottle in her left.
Iraq, 10th century AD.

16

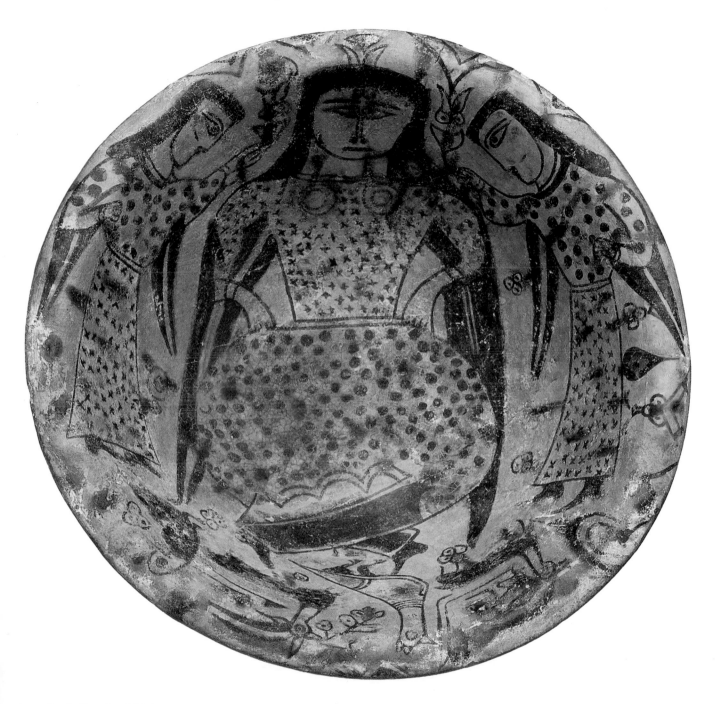

8. **Bowl,** slip-painted, Nishapur polychrome ware, showing a seated female figure approached by two angels.
 Iran, Nishapur, 10th century AD.

9. **Large bowl,** slip-painted, black-on-white ware, decorated with an inscription, beautifully written in floriated and plaited Kufic. *Iran, Nishapur, 10th century AD.*

10. **Large bowl**, slip-painted, polychrome-on-white ware, the simple Kufic inscription is a quotation from the Qur'an *Surat al-Qalam*, verses 51-52, reading: *"...and the Unbelievers would almost trip Thee up with their eyes when they hear the Message; and they say: "Surely he is possessed. But it is nothing less than the Message to all the worlds."*
Uzbekistan, Samarqand, dated: 300AH/AD912.

11. **Large bowl,** slip-painted, yellow-staining-black ware, it is decorated with floriated pseudo-Kufic inscriptions running all around the cavetto; one is facing outward, the other inward. The word across the base reads: *"Ihmid", "Give thanks" (to God)*
Iran, probably Nishapur, 10th century AD.

20

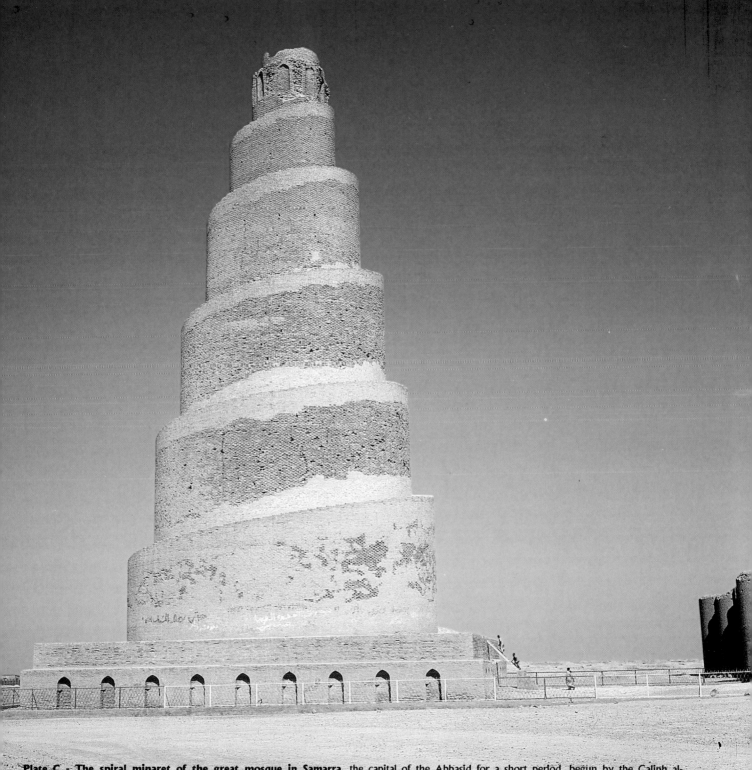

Plate C - The spiral minaret of the great mosque in Samarra, the capital of the Abbasid for a short period, begun by the Caliph al-Mutawakkil in 233AH/AD847. The mosque is the greatest in the Islamic world. (Photo Tareq S. Rajab - 1962)

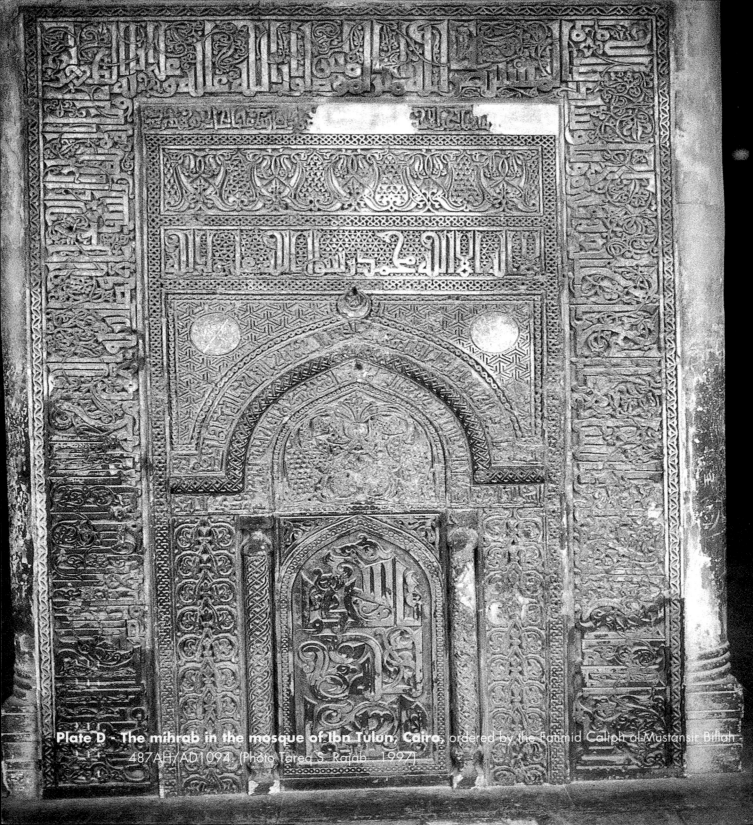

Plate D - The mihrab in the mosque of Ibn Tulun, Cairo, ordered by the Fatimid Caliph al-Mustansir Billah 487AH/AD1094. (Photo Tareq S. Rajab 1992)

3. POTTERY OF THE FATIMID PERIOD IN EGYPT AND NORTH AFRICA

The Fatimid period (297AH/AD 909 - 567AH / AD1171) can be regarded as a renaissance for the arts. The dynasty came to power in North Africa, claimed descendance from Caliph Ali and accordingly, they were followers of the shi'a doctrine. They established themselves in Tunisia, then in 359AH/AD969 occupied Egypt and established Cairo, or its Arabic name *"al-Qahira"*, "the Victorious". Soon they extended their power over Syria and the two holy cities of Mekka and Medina. The Fatimids were great patrons of the arts and metalwork, pottery and glass manufacture flourished. Outstanding rock-crystals and ivory carvings were produced. Beautiful mosques, like the al-Azhar and al-Hakim were erected. That was also the earliest period from which parts of illustrated manuscripts have survived. For pottery production, it was a Golden Age and we may mention here three major types: vessels covered with a coloured monochrome glaze, lustre-painted wares and the so-called North African polychrome-painted in-glaze wares.

Refined monochrome glazed wares were coated with a coloured monochrome glaze and decorated with incised or moulded decoration underneath. They were first made of yellowish-buff or red earthenware and later of faience, or the so-called "composite white fritware" (more about it in the next part). They appeared in Egypt towards the end of the period, probably in the 12th century. A cobalt-blue glazed bowl with incised floral decoration in the Museum is an excellent example of the earlier type made of buff earthenware (**no. 12**). Similar vessels were brought to light by the Kuwaiti excavations at Bahnasa in Upper Egypt and numerous such vessels are preserved in the Museum of Islamic Art in Cairo and the Benaki Museum, Athens.

Lustre went through significant development during the late 10th and early 11th century. The Fatimid period witnessed further progress, not so much in technique, but rather in the decoration of vessels. Figural designs played a more important role. The drawings are not so naive anymore, the figures are shown in movements, frequently involved in everyday activities. A few names of outstanding artists are known from this period, with their signatures on the vessels. One of them was called *Baytar*. He was active towards the end of the 10th and early 11th century. The large green glazed lustre-painted jar bears his signature in two places (**no. 13**). The vessel still belongs to the early phase of Fatimid lustre as we can judge from the naively drawn standing figure, who is represented in three oval medallions. In one, he holds a banner, in the other a large stick and in the third one a drum. The artist's name appears above, in two of the ovals. Something went wrong in firing, since the lustre turned out to be too dark, almost black. Another Fatimid lustre vessel, a bowl with everted sloping rim is decorated in the centre with a large animal, probably a lion, its tail ends in a leaf and beneath there is an almond-shaped pattern (**no. 14**). The rest of the central area is dotted. The everted rim carries a foliated Kufic inscription which may be read as *"baraka li-sahibihi"* (twice), "blessing to the owner", then perhaps: *"tawakkal tukfa"*, "trust (in God) is sufficient" and: *"sal tu'ta"*, "ask (from God) and it will be given".

The recent Kuwaiti excavations at Bahnasa/Oxyrhynchus in Upper Egypt revealed, that it was one of the most important pottery centres in the country both in pre-Islamic and early Islamic times. Many decades ago an important lustre-painted large dish was discovered there, its decoration presents a sailing ship. The excavated fragments and pottery kilns indicated,

that at least some of the Fatimid lustre-painted pottery was made at this centre (**plate E**).

In the North African provinces, i.e. Morocco, Algeria, Tunisia, Libya, also in Spain, a special type of pottery was produced which was in a way a further development of the Near Eastern splashed ware. The vessels were painted in green, yellow and manganese against a mustard or dark yellow background. The manganese was mainly used for outlining the designs (cf. **plates F and G**). There are two distinct types: those which had a coloured ground slip on which the decoration was painted, then covered with a clear lead glaze; or those with no ground slip and the decoration painted directly on the body and then coated with the glaze. On these latter examples the paint normally runs. The designs are frequently based on floral patterns or calligraphy and rarely figural. A bowl in the Tareq Rajab Museum was coated with a yellow ground slip and painted with green crosshatchings within manganese ovals (**no. 15**). However, the presence of the slip did not prevent the colours from running under the clear glaze. That was probably due to the fact that the decoration was painted on the slip while it was still wet. Such misfortunes are quite common on this type of North African pottery.

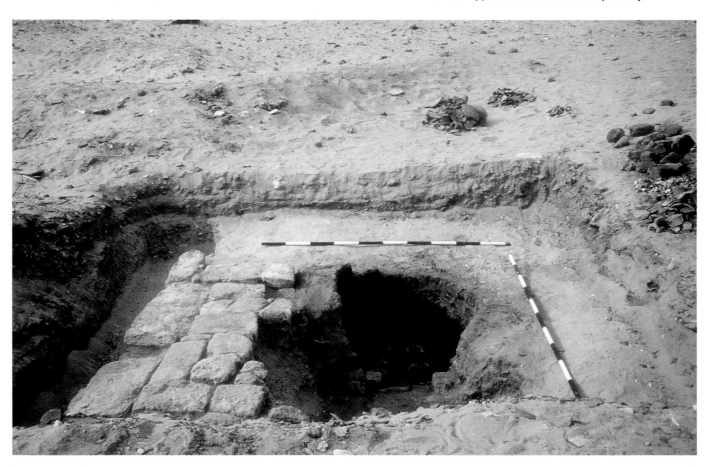

Plate E - Bahnasa/Oxyrhynchus, one of the pottery kilns which was excavated by the archaeological team from Kuwait in 1987. (Photo Géza Fehérvári)

24

Plate F - Fragment of a polychrome in-glaze painted ware., excavated at *Medinet Sultan, Surt al-Qadima, Libya, 10th or 11th century A.D.* (Photo Géza Fehrévári)

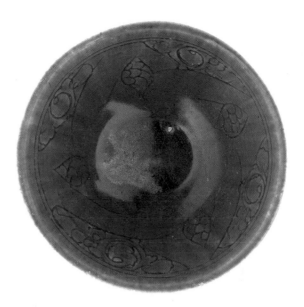

12. **Bowl,** made of buff earthenware, showing incised floral decoration under the transparent cobalt-blue glaze. It was fired on its side and therefore the glaze collected in a pool on one side of the base.
Egypt, Fatimid period, 12th century AD.

Plate G - Fragment of a polychrome in-glaze painted ware, excavated at *Medinet Sultan, Surt al-Qadima, Libya, 10th or 11th century A.D.* (Photo Géza Fehérvári)

Detail from No. 12.

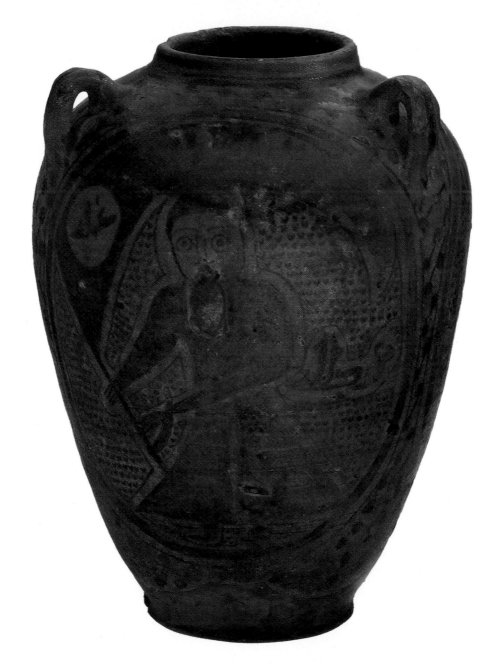

13. **Large jar**, buff earthenware, covered with a green glaze and painted with lustre, signed: *"amalahu Baytar"*, *"made by Baytar"*.
Egypt, Fatimid period, late 10th - early 11th century AD.

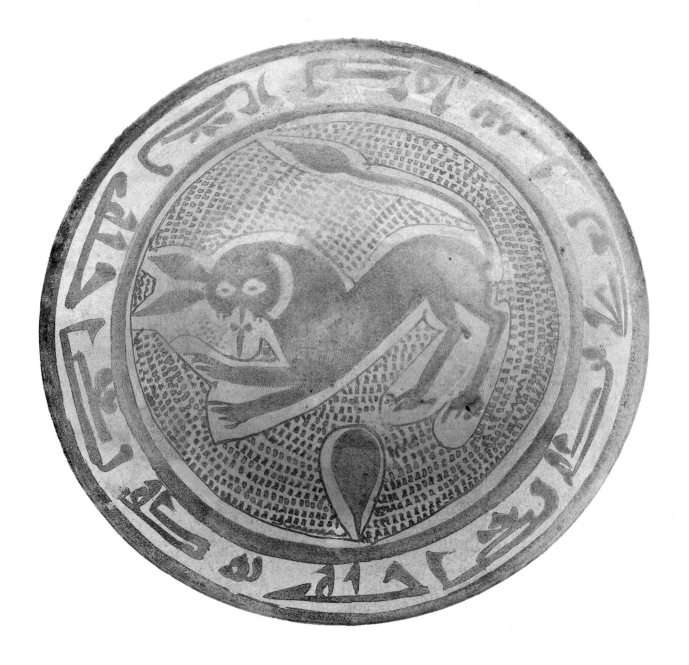

14. **Bowl**, decorated with yellowish-green lustre, showing a lion in the centre; the foliated inscription on the rim reads: *"baraka li-sahibihi"* (twice), *"blessing to the owner"* , then *"tawakkal tukfa"* *"trust in God"* and *"sal tu'ta"*, *"ask (from God) and you will be given"*. *Egypt, late 10th - early 11th century AD.*

27

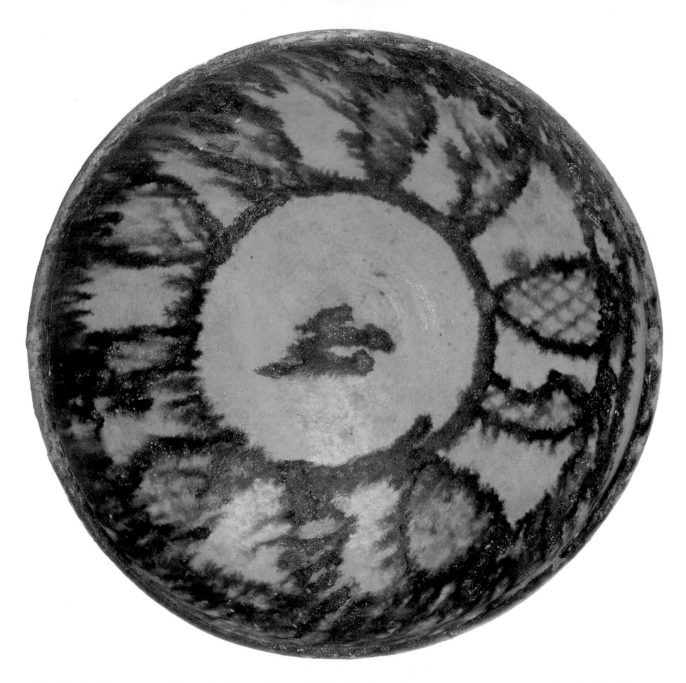

15. **Bowl,** red earthenware, inside coated with a thin ground yellow slip, then painted in green and manganese under a clear lead glaze. *North Africa, probably Tunisia, 11th - 12th century AD.*

4. SELJUQS, GHAZNAVIDS AND GHURIDS

Soon after the Fatimids came to power in Egypt, further East the Seljuqs entered Iran and their leader, Toghrul declared himself Sultan, the ruler of Iran in 429AH/AD1038. In less than twenty years, they entered Baghdad and became "protectors" of the Abbasid Caliphs. Like the Fatimids, the Seljuqs were also great patrons of the arts. Their advent opened a new chapter in the history, not only in Iran but in the entire Islamic world. Hundreds of new mosques, medreses, palaces and caravanserais were built and decorated with richly carved stucco panels, brickwork or, towards the end of the period, with glazed tiles. For pottery it was a Golden Age. We can distinguish two major types of glazed wares from this period: those made of earthenware and vessels made of the newly introduced "composite white fritware".

To the first type belong the so-called *sgraffiato* wares. *Sgraffiato* was not a new invention. It was already used by the Copts of Egypt in pre-Islamic times. In Islamic times it appeared already in the 10th century in combination with splashed pottery. *Sgraffiato* is a technique, in which the decorative designs are incised by a sharp tool into the body or carved out of the ground slip, then coated with a coloured or colourless transparent lead glaze. Amongst the earliest types, we have the simple *sgraffiato*, when the decoration was incised and then covered with a coloured glaze, or if the slip was coloured, a colourless glaze was used. An interesting and fine example of the first type is the bowl which is covered with a ground yellow slip with the floral decoration incised into it (**no. 16**).

A more colourful version is known under the wrong term of "Amol" ware. The name derives from the small town of Amol in Mazandaran, close to the Caspian Sea, where large numbers of such vessels were discovered. On these vessels, the incised lines are painted in green, occasionally in red under the colourless lead glaze. The small bowl, an attractive example of the "Amol" wares, depicts a swimming fish and wavy lines which may represent the waves of the sea (**no. 17**).

Another important group is one in which the decoration was not incised, but carved out of the ground slip and then, depending on whether the slip was coloured or not, covered with a coloured or colourless lead glaze. This type is known as *champlevé*, or carved ware. The decoration of the carved bowl presents an enthroned ruler or a prince under a green lead glaze (**no. 18**).

A further version is known as "Aghkand" ware, after the village of Aghkand in north-western Iran where, it is claimed, this type of *sgraffiato* was made. This is a polychrome painted version of the *sgraffiato* pottery and the incised lines serve one purpose to separate the different colours from each other. Most of these vessels are decorated with large birds or animals, like the large bowl in the Tareq Rajab Museum which depicts a cockerell against a scroll background (**no. 19**).

Shortly before the fall of the Samanid dynasty in 366AH/AD977, a Turkish commander, Sebukteqin came to power in Central Asia. Soon, his son, Mahmud, declared himself fully independent and became the founder of the Ghaznavid dynasty. They ruled over what is now Afghanistan, Khurasan, Baluchistan and the north-western part of India from their capital at Ghazni. They were replaced by the Ghurids in 582AH/AD1186. The Ghurid period was short lived, they were defeated by the Khwarazmshahs of Iran in 612AH/AD1215. Five years later, the Mongol invasion put and end to their rule and to the Iranian renaissance and devastated most of the areas that once belonged to the Ghaznavids, Ghurids and

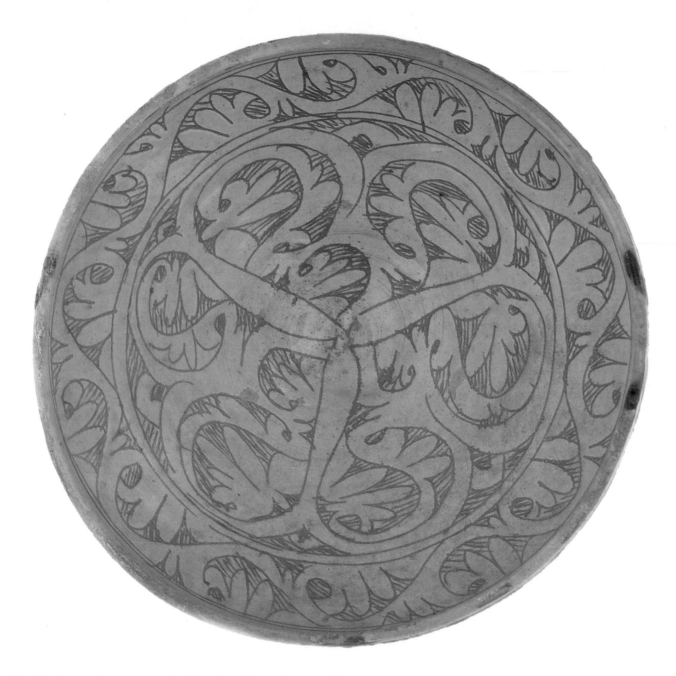

16. Bowl, red earthenware, coated with a yellow slip and decorated with incised floral designs under the colourless lead glaze. *Iran, 12th century AD.*

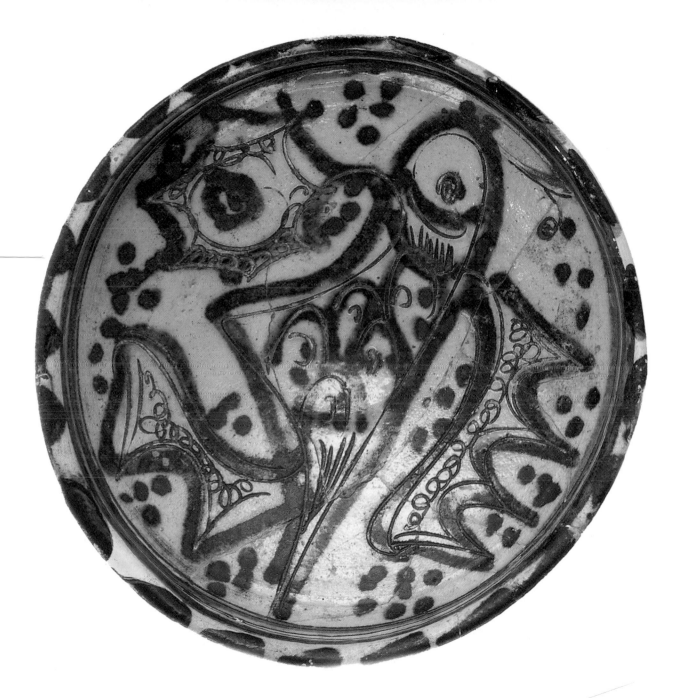

17. **Small bowl**, "Amol" ware, red earthenware, with incised and green painted decoration under a colourless glaze.
Iran, Mazandaran, 12th century AD.

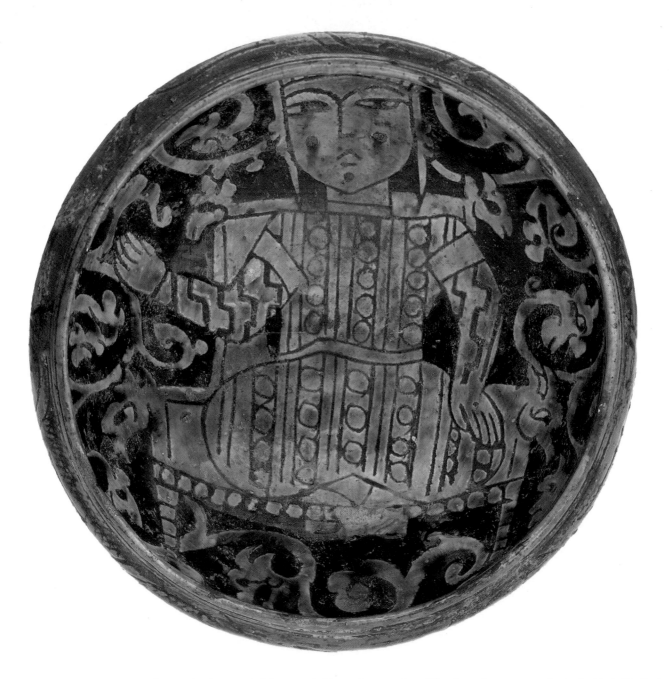

18. Bowl, *champleve* or carved ware, showing a seated figure, probably a ruler or a prince. The decoration was carved out of a black slip, then the entire vessel was coated with a transparent green lead glaze.
Iran, Garrus district, 12th century AD.

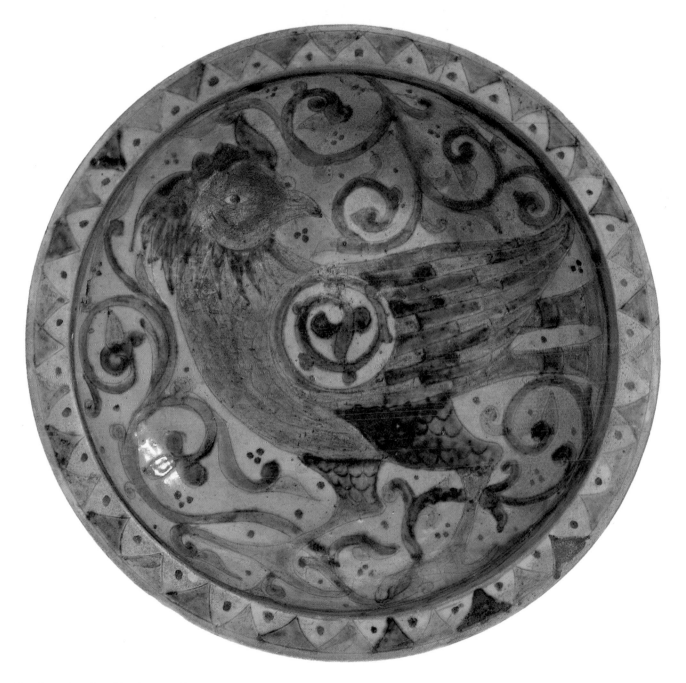

19. **Large bowl**, Aghkand ware, with a cockerel against a floral scroll ground, painted in green, yellow and manganese.
Iran, Aghkand district, 12th century AD.

33

20. **Deep pedestal**, or "Bamiyan" bowl. Buff earthenware, coated with a creamy ground slip into which the *sgraffiato* designs were incised and splashed with green and manganese.
Afghanistan, Bamiyan, 12th - early 13th century AD.

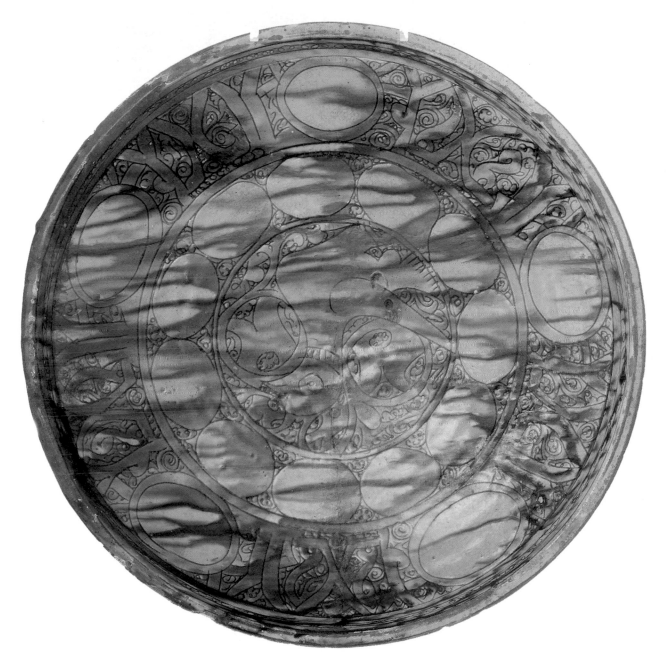

21. **Large dish,** red earthenware, coated with a ground yellow slip into which the decoration was incised, then splashed with green and manganese.
Afghanistan, probably Bamiyan, 12th - 13th century AD.

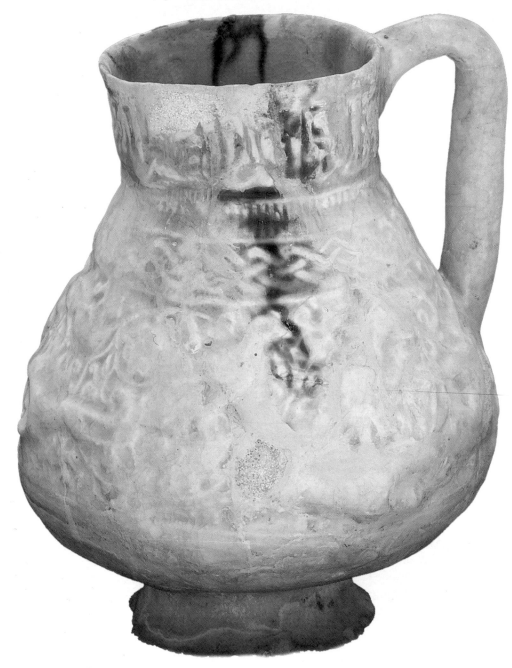

22. Jug, Seljuq white ware, with moulded, pierced and cobalt-blue painted decoration, showing animals, including a dragon.
Iran, probably Kashan, 12th - early 13th century AD.

the Khwarazmshahs. But prior to the Mongol invasion, remarkably fine pottery was produced in Central Asia, particularly in Afghanistan, with their centres based at Ghazni and Bamiyan. Although the *sgraffiato* pottery of Afghanistan betrays its strong relationship to those of Iran, both shapes and decorations are considerably different. The typical "simple" *sgraffiato* vessels are deep pedestal bowls, also known as **"Bamiyan bowls"** since they were excavated at Bamiyan. They have everted rims and rest on splayed foot-rings. The incised decoration was applied on both sides, but outside only on the upper part (**no. 20**). What makes these "Bamiyan bowls" so attractive is the extensive use of manganese and green splashes. The second *sgraffiato* type can be seen on large dishes. Although it is not certain, but most likely they were also made at Bamiyan. There are a few examples of these in the Tareq Rajab Museum, among them a large dish which is decorated with an incised bird in the centre (**no. 21**). Perhaps the green and manganese splashes were too extensive on this dish, thus it makes it more colourful and attractive.

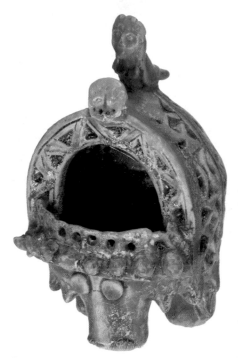

23. **Incense-burner**, monochrome glazed ware.
Iran, probably Kashan, 12th - early 13th century AD.

The second major type of pottery in Iran and also in the neighbouring countries was made of a newly introduced faience, or more properly called "composite white fritwares". It was sometime during the 11th century AD that this new body material was introduced. As it has been already mentioned, this kind of faience was first invented and introduced by the ancient Egyptians as early as the late 5th or early 4th millennium BC. This Egyptian faience was coated with a beautiful turquoise-blue alkaline glaze. Later it went out of "fashion" and was forgotten. It was re-invented probably in Fatimid Egypt during the 11th century. There is a treatise, written by a Persian, called Abu 'l-Qasim of Kashan, in 701AH/AD1301, who describes this new body material. He claims that it was made of ten parts of ground quartz, one part of clay and one part of glaze mixture. This new body material came very close to the whiteness and fineness of

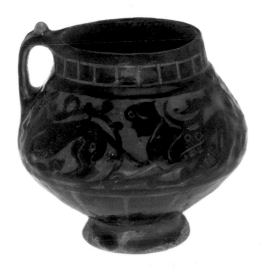

24. **Jug**, silhouette ware, showing running animals.
Iran, 12th century AD.

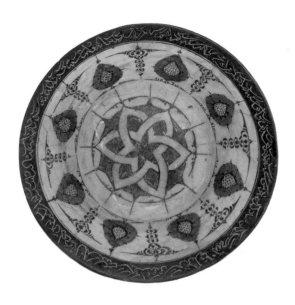

25. **Bowl**, painted in black and cobalt-blue under clear glaze.
Iran, Kashan, 13th century AD.

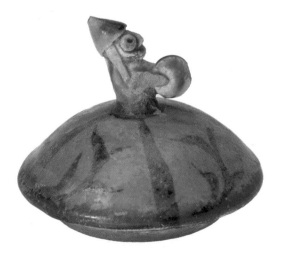

26. **Lid**, with painted decoration under turquoise-blue glaze. The
small seated figure serves as a handle.
Iran, 13th century AD.

contemporary Chinese porcelain. To imitate the Chinese *ch'ing-pai* porcelain, Persian potters went even further, they produced thinly potted vessels made of this new composite white fritware and coated them with a colourless glaze. This ware is known under the name of ***"Seljuq white"***. Some of them are simple white vessels, without any surface decoration, others are moulded, pierced, carved and painted in cobalt-blue or manganese. One of the finest examples of these "Seljuq white" wares in the Museum is a jug (**no. 22**). Its moulded decoration depicts animals, including a dragon. The body is pierced, so when seen against a light it looks translucent.

Similar composite white body was used for vessels and tiles which were coated with **coloured monochrome** alkaline glaze. The colour of the glaze could vary from different shades of blue and green to yellow, brown and mauve. Just as the colours varied, so did the shapes and types of vessels on which these colourful alkaline glazes were applied. A rare and prominent piece in the Museum's collection is an incense-burner (**no. 23**). Its shape imitates contemporary metal vessels. It is covered with a turquoise-blue glaze.

An interesting type of pottery was developed in Iran during this period, the so-called **silhouette ware**. Actually it was the equivalent of the *champlevé sgraffiato*, the difference being that silhouette wares were made of composite white fritwares. The vessels were coated with a thick black slip and the decoration was carved out of it, then the surface was covered with a colourless or coloured alkaline glaze. The Tareq Rajab Museum has the coloured glazed type, among them a jug with a squat body (**no. 24**). On its upper part a decorative band depicts four running animals.

Silhouette wares could have served as prototypes for the **underglaze-painted** wares and from the 12th century onward played an important role in the history of Islamic pottery. Instead of carving the

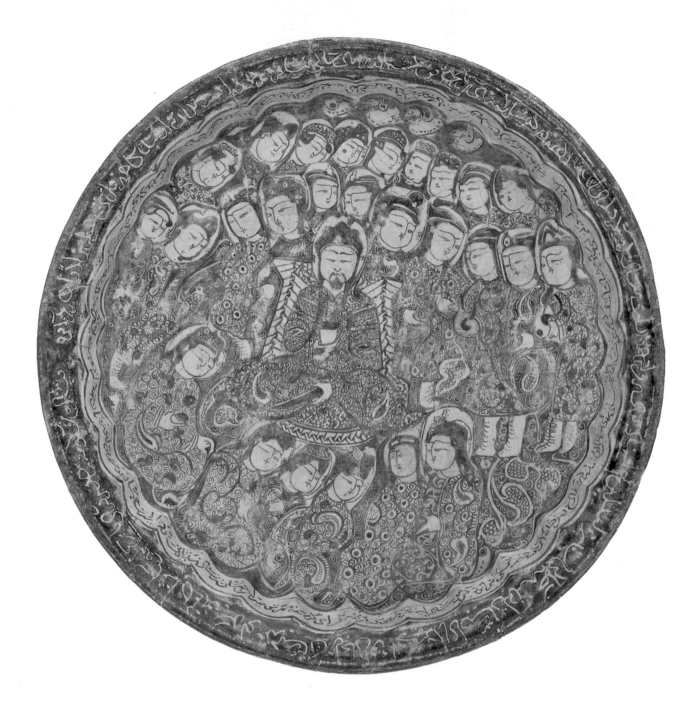

27. Large tray, lustre painted showing an enthroned monarch or prince, with his courtiers and attendants. *Iran, Kashan, early 13th century AD.*

39

designs out of a thick black slip it was easier, quicker and most likely cheaper to paint the designs with a brush under a transparent alkaline glaze which could be either colourless or coloured. The colours used for painting were black, blue and turquoise under a colourless glaze. Under a coloured glaze, mainly black was applied, although there are examples when even a dark blue is present under a light blue glaze. A bowl in the Museum with its black and cobalt-blue painted decoration under a colourless glaze is a good example of the first group (**no. 25**), while a small turquoise-blue glazed lid with black painting underneath, illustrates the second one (**no. 26**). This piece is quite an unusual one, since instead of a simple handle it has the figure of a seated man on top.

Lustre-painting reached its Golden Age in Iran during the late 12th and early 13th century. The most important production centre was at Kashan in Central Iran, although archaeological evidence indicates that the town of Gurgan (or in its classical name Jurjan) also produced lustre wares (**plate H**). There are several vessels and tiles bearing the signature of Kashani artists and the date of completion. The Tareq Rajab Museum has a large number of lustre-painted pottery and tiles from this period. One of them is a large tray with a flat base with rising lobed sides and everted flat rim (**no. 27**). The shape of this vessel was clearly borrowed from contemporary metalwork. The decoration of the tray presents an enthroned monarch or a prince, surrounded by courtiers and attendants. The scene is surrounded by a cursive inscription, so far undeciphered, which runs around in the lobed sides. A second epigraphic band is on the rim. This type of tray may have been popular in pottery since there are a few contemporary examples, two of them dated. One is in the Victoria and Albert Museum, London, showing a horseman against a dense scroll background. It is dated 604AH/AD1207. The other one is in the Freer Gallery, Washington, dated

607AH/AD1210. The Tareq Rajab Museum's tray is about the same date, i.e. early 13th century AD.

Another vessel in the Museum is a large dish (**no. 28**). It appears to be an incomplete vessel, since the paintings on some parts of the designs are missing. Nevertheless it is an interesting and may even be an important object for two reasons: Firstly because it shows that the decoration was intended to be painted not only in lustre, but also in overglaze polychrome, in the so-called *mina'i* technique (more about it further below). That this was the artist's intention is indicated by two details: 1) all the designs and patterns are outlined in red and 2) the major scene, namely two horsemen meeting at a tree, is a favourite one on *mina'i* pottery. Admittedly, it also appears on lustre-painted vessels. However, when we examine the dish properly, we immediately notice that while the lustre painting is complete, there are areas left blank, obviously awaiting the artist's brush to colour them. The second main reason why this vessel is significant, because there are very few vessels which show a combination of lustre and overglaze painting. This was most likely made, or decorated by an artist who used to work both in lustre and in the overglaze technique.

The last type of pottery that developed during this period was painted over the glaze. **Overglaze-painting** is better known under its Persian name *mina'i* "enamelled", or *heft-rengi*, "seven coloured" ware. It means that seven colours were used on this ware, but not necessarily all together. They were painted over the glaze, except the blue which is always underneath. The decorations may be entirely floral or geometrical, while others reveal figural decorations. They often present scenes from the Persian national epic, the *Shahnama*, the "Book of Kings". Others may show portraits of young couples or single figures. One of the most frequent representations, as mentioned above, is the scene of two horsemen meeting at a small pond under a tree (**no. 29**). According to Abu

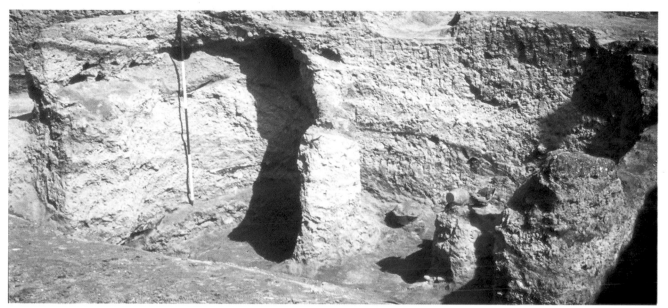

Plate H - Gurgan (or Jurjan), remains of a pottery kiln, excavated by Dr. Mohammad Yousef Kiani in 1974. (Photo Géza Fehérvári)

'l-Qasim's treatise (mentioned above), overglaze-painted pottery was made at Kashan, but only for a short period. It was introduced around 1170AD and discontinued after then Mongol invasion in 1220AD. It re-emerged after the mid-13th century, but in a different form (cf. below).

The same types of "Seljuq" wares were also much favoured and produced in Afghanistan and Central Asia. Accordingly, excavations there brought to light Seljuq white, coloured monochrome-glazed and underglaze-painted wares. Although lustre-painted pottery was found in Afghanistan, they were most likely imported from Iran. Up-to-date, there is no evidence for their production either in Afghanistan, or anywhere else in Central Asia. The same remark also applies to over-glaze-painted pottery. These Afghan fine wares are well represented in the Tareq Rajab Museum and one of them is an outstanding "Seljuq white" small bowl decorated with pierced, moulded and painted decoration in manganese and cobalt-blue (**no. 30**). Another prominent piece is a

small dish with an intricate moulded design, showing a Buddhist knot in the centre, surrounded by a floral scroll and covered with a turquoise-blue glaze (**no. 31**).

Potters during the 12th and 13th centuries produced large number of monochrome-glazed and lustre-painted *mihrab* tiles. These could be small and single rectangular tiles showing a pointed or a lobed arch supported by columns. They may have been used on their own, either in a mosque, a medrese, or in a tomb, in palaces or even in private houses. Others, particularly the lustre-painted examples, were made-up of several tiles and were part of a large composition. Several of these survived either *in situ* in mosques, while others are preserved in public or private collections. A rectangular, green glazed *mihrab* tile in the Tareq Rajab Museum (**no. 32**) has a pointed lobed arch which is supported by a pair of columns and is covered with a green glaze. It may have come either from Khurasan or from Afghanistan.

41

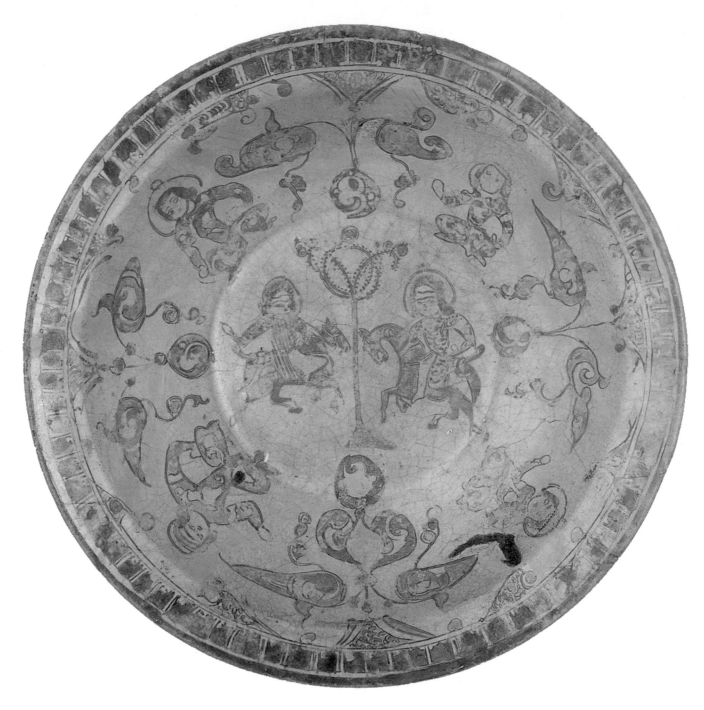

28. **Large dish**, painted in lustre and overglaze red, with two splashes of cobalt-blue. *Iran, probably Kashan, early 13th century A.D.* (Photo Tareq S. Rajab)

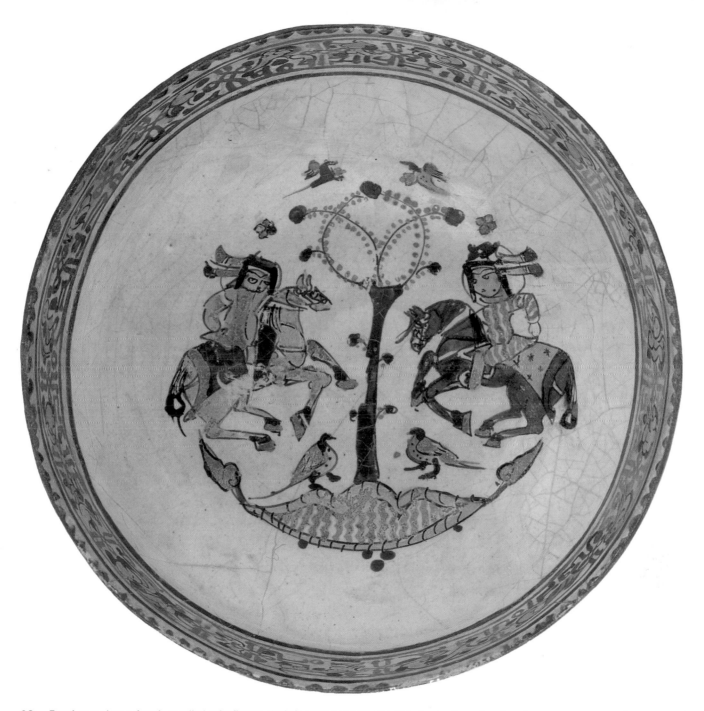

29. Bowl, overglaze-painted, so-called *mina'i* ware, depicting two horsemen meeting at a small pond under a tree. *Iran, probably Kashan, late 12th or early 13th century AD.*

43

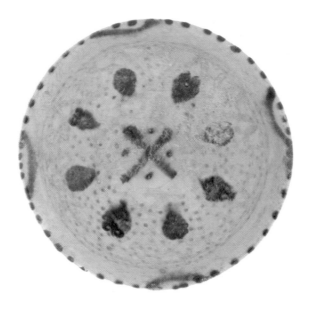

30. **Small bowl**, so-called "Seljuq white" ware, with moulded, and pierced decoration, with splashes of manganese and cobalt-blue.
Afghanistan, 12th - early 13th century AD.

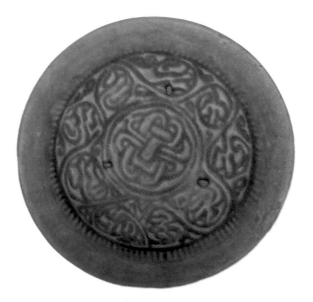

31. **Small dish**, coated with a turquoise-blue glaze, showing an intricate moulded design.
Afghanistan, 12th - early 13th century AD.

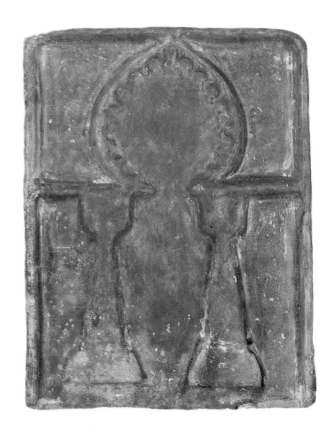

32. **Mihrab tile**, rectangular, covered with a green glaze.
Iran or Afghanistan, 12th - early 13th century AD.
(Photo Tareq S. Rajab)

44

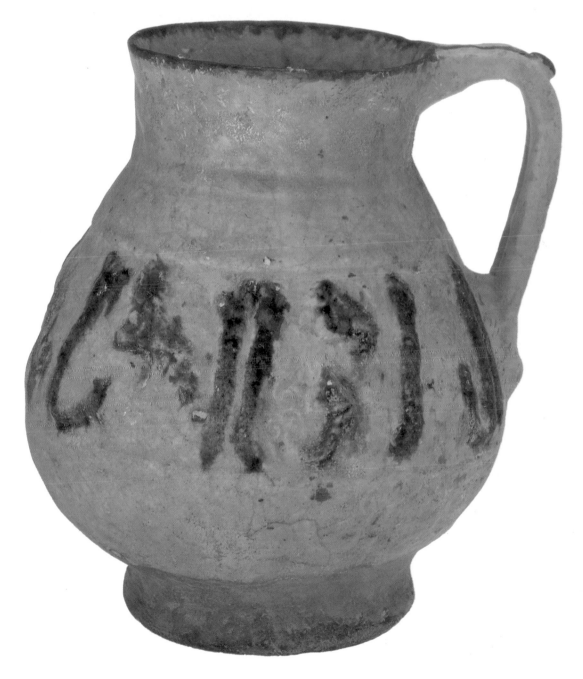

33. Jug, *laqabi* ware, buff earthenware, with a moulded epigraphic band of a benedictory inscription, reading: *"Glory, prosperity, power, good fortune and honour."*
Syria, 12th century AD.

5. POTTERY OF SYRIA AND EGYPT BETWEEN THE 12TH AND 15TH CENTURIES

The Fatimids were overthrown by the Ayyubids in 567AH/AD1171 and they ruled over Egypt and Syria until 648AH/AD1250, when in turn, they were replaced by the Mamluks. Mamluk rule ended when the Ottomans invaded both countries in 922AH/ AD1516 and annexed them to the Ottoman Empire.

Syria had a long tradition in pottery manufacture going back to several millennia. Under the Fatimids Egyptian influence became prevalent, particularly in lustre painting. Later on in Seljuq times, the influence of Iranian pottery became more visible. Especially so after the Mongol invasion, when many Iranian artists took refuge in Syria. At that time the most important pottery centre was at Raqqa. A second archaeological site where, a large amount of pottery came to light was at Tell Minis, between Hama and Aleppo. Although up-to-date no pottery kilns were discovered at Tell Minis, it is evident from the excavated sites that the pottery from there was manufactured at some other centre than Raqqa, since its quality is far superior to that of Raqqa. It has recently been suggested that Tell Minis wares were perhaps made at Balis/Meskeneh, an archaeological site on the right bank of the Euphrates, between Aleppo and Raqqa, where a pottery kiln was also discovered.

Syrian and Egyptian pottery of the period under discussion, which is well represented in the Museum, may be divided into the following groups: the so-called *laqabi* wares, monochrome-glazed, underglaze-painted, lustre-painted, *sgraffiato* and blue and white wares.

Laqabi, or more correctly *la'abi*, means "enamel" in Persian. In essence it is a kind of *sgraffiato* ware, when the designs are partially incised and partially in relief. They are intended to separate the different colours which were used on the same vessel. Therefore it is a *cloisonné* technique applied to ceramics. Most *laqabi* vessels are large plates or dishes showing walking birds or animals. There is a rare piece of *laqabi* in the Museum, a jug with a moulded epigraphic band painted in manganese and cobalt-blue (**no. 33**). Since most of the *laqabi* vessels were made of composite white fritware and the Museum's jug is of buff earthenware, it can therefore be regarded as one of the earliest of this type of pottery.

"Seljuq white" and coloured **monochrome-glazed** wares were very popular in Syria and may have been made at several centres. Earlier examples had buff or red earthenware bodies, but were later made of composite white fritwares. Like the Iranian examples, they were also decorated with incised, moulded or pierced designs and the white wares occasionally painted with underglaze blue. One major difference may be that most of these Syrian vessels over the glaze have a layer of iridescence, which appears like lustrous patches. A prominent example of the Syrian coloured monochrome-glazed wares in the Tareq Rajab Museum is a hexagonal table with moulded, incised and openwork decoration and coated with a cobalt-blue glaze which in places is highly iridescent. The top has a circular hole to provide space for a lamp (**no. 34**).

Besides the coloured monochrome-glazed ware **underglaze-painted** pottery was perhaps the most popular. The earlier examples were made at Raqqa, but the town was invaded and destroyed by the Mongols in 656AH/AD1258. Afterwards, most of the potters moved to Damascus which became a major pottery centre in Mamluk times. An unusual and attractive Syrian underglaze-painted ware in the Tareq Rajab Museum is a large bird coated with turquoise-blue glaze and painted in black underneath

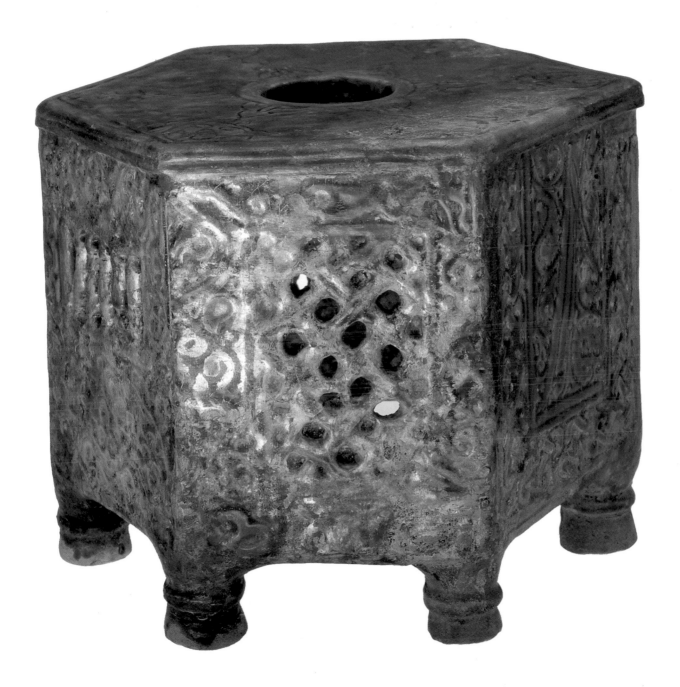

34. Hexagonal table, monochrome glazed ware, with extensive moulded, incised and openwork decoration.
Syria, first half of the 13th century AD.

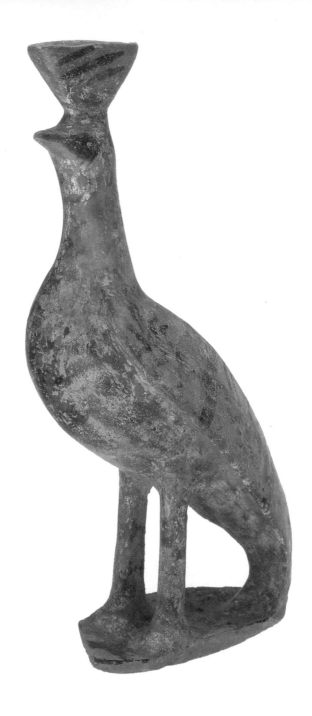

35. Large bird, coated with a turquoise-blue glaze and painted in black under the glaze painted.
Syria, probably Raqqa, late 12th - early 13th century AD.

48

36. **Bowl,** painted in polychrome under a clear glaze. The inscriptions are typically Mamluk, reading: *"Glory to our Lord, the / King, helped by Heaven / the Sultan..."*
Syria, probably Damascus, Mamluk period, 14th - 15th century AD.

(**no. 35**). Several similar examples are known and they were identified as fountain figures, which may have been the function of this bird as well. The polychrome painted bowl showing a flower within a hexagonal star reveals an entirely Mamluk style (**no. 36**). There are six wedge-shaped panels radiating from the centre, three of which are decorated with epigraphic bands, reading: *"Glory to our Lord, the / King, helped by Heaven / the Sultan...."*, which is typically a Mamluk inscription.

The panel of nine hexagonal tiles was most likely produced by artists from Tebriz who were active both in Syria and Egypt during the 15th century (**no. 37**). The tiles reveal Chinese influence. The decoration is mainly based on floral patterns, surrounded by scrollwork. One of them depicts a ewer, a frequently used motif on these tiles.

Lustre-painted pottery was already made in Syria in Fatimid times. Their production continued during the Ayyubids, i.e. in the late 12th - first half of the 13th century, perhaps at Balis/Meskeneh and also in Raqqa. The Museum has a number of outstanding Syrian lustre vessels of the Ayyubid period. They are in the style of Raqqa, where they applied a chocolate-brown lustre for decoration, occasionally combined with cobalt-blue or turquoise. The large jar is one of the well-known Raqqa types (**no. 38**). It has a moulded surface and the decoration is painted in chocolate-brown lustre. The chamber-pot, surprisingly a frequently discovered vessel in Syrian excavations, has the same chocolate-brown lustre with heavy vertical lines painted in cobalt-blue (**no. 39**).

Imported Chinese blue and white porcelain appeared in Syria and Egypt as early as the second half of the 14th century. Excavations in Syria brought to light Chinese originals and their local imitations which may be dated to the late 14th and early 15th century. At the beginning, Syrian and Egyptian potters carefully copied the designs from Chinese porcelain, but gradually added and developed their own style. At present, there is no definite evidence where the Egyptian and Syrian blue and white were made, but it is generally accepted that one place was Damascus. The blue and white vessels in the Museum are all from Syria. One of them is a hemispherical dish with everted flat rim decorated with floral scrolls in Chinese style (**no. 40**). It may be a late 14th or early 15th century vessel. The second is a blue and white jar with an extensive cobalt-blue decoration, showing flowers within lobed cartouches and framed by zigzag lines (**no. 41**).

Sgraffiato wares of Syria and Egypt were quite distinct from those of Iran. During the Ayyubid period a polychrome-painted version was popular and widespread in Syria which reveals some relationship to contemporary Persian Aghkand wares. Whether this type was introduced from Iran, or vice versa from Syria to Iran, is still not clear. Archaeological evidence indicates that this type of pottery was well established in Syria during the 12th century. A bowl with straight flaring sides and everted flat rim, painted in yellow, green and manganese, showing floral patterns, is an outstanding example of the Syrian *sgraffiato* wares (**no. 42**).

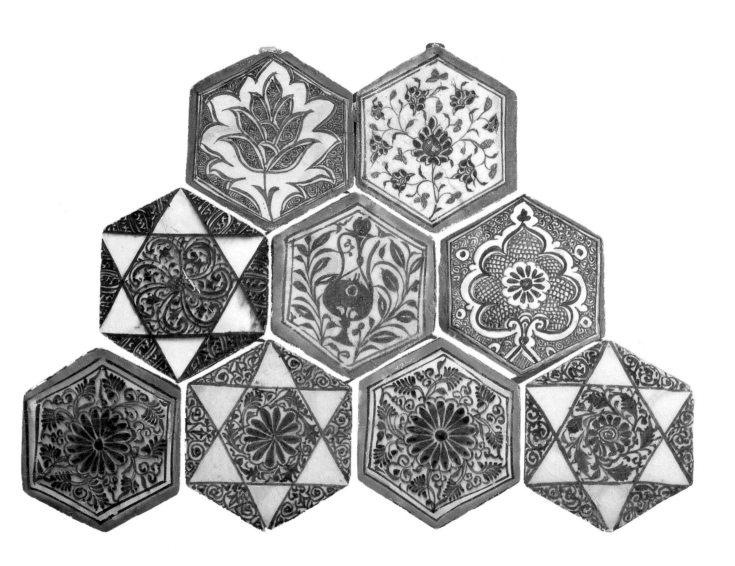

37. Panel of nine Damascus tiles, hexagonal tiles, painted in black and blue, some also in turquoise.
Syria, probably Damascus, Mamluk period, 15th century AD.

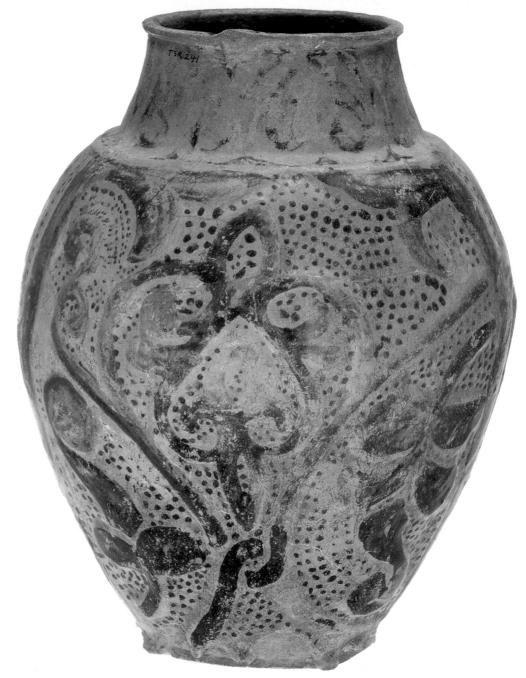

38. **Large jar,** with moulded and chocolate-brown lustre painted decoration with some cobalt-blue and turquoise colours. *Syria, Raqqa, 13th century AD.*

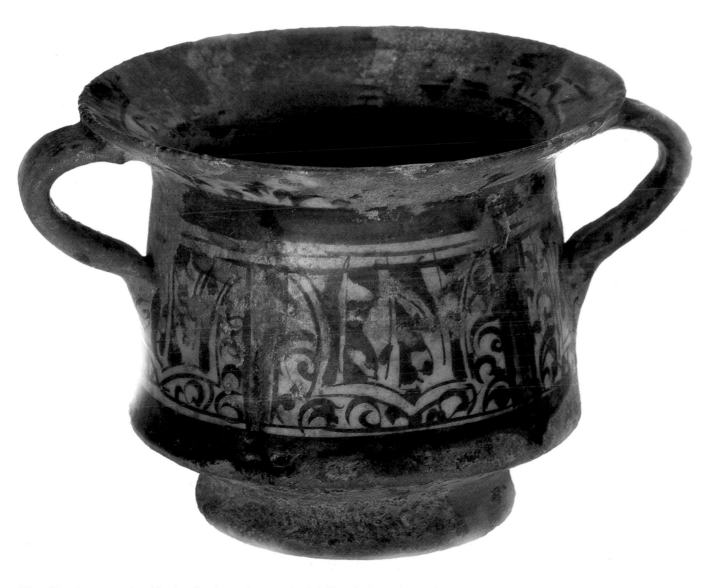

39. Chamber pot, painted in chocolate-brown lustre and cobalt-blue. Such vessels were very popular in Syria and large number of these were found in excavations.
Syria, Raqqa, 13th century AD.

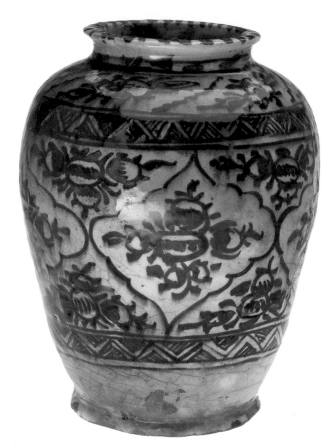

41. **Jar**, blue and white ware.
Syria, Mamluk period, 15th century AD.

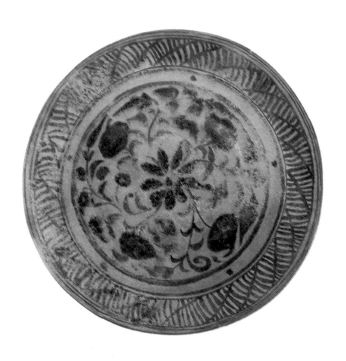

40. **Dish**, blue and white ware.
Syria, Mamluk period, late 14th - early 15th century AD.

54

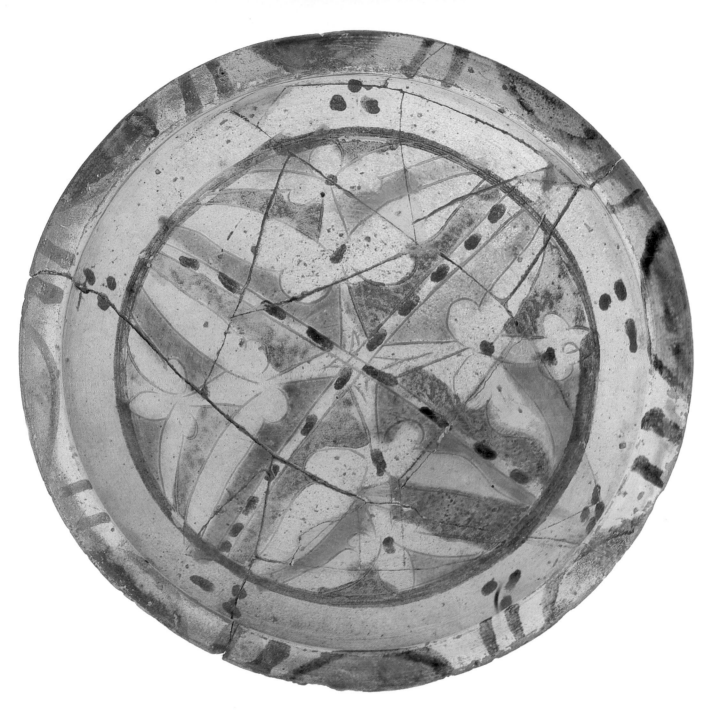

42. **Bowl**, *sgraffiato* ware, with incised decoration and painted in yellow, green and manganese.
Syria, 12th century AD.

In Egypt, where it originated, **sgraffiato pottery** always played a prominent role. A large number of vessels were excavated which were incised or carved and were coated with green, yellow, brown or even purplish glaze. The earlier *sgraffiato* vessels may be dated to the period between the late 11th and 13th centuries, i.e. to the late Fatimid and Ayyubid periods. By early Mamluk times further changes can be observed on Egyptian *sgraffiato*. The vessels were coated with a ground white slip and the incisions became deeper and therefore more apparent. The shapes of vessels were modified, sometimes imitating Syrian or Iranian vessels. An interesting example of this early Mamluk *sgraffiato* is a green glazed cup bowl which is covered with a ground white slip into which the incisions were applied (**no. 43**). They decorate the vertical sides of this unusual vessel.

By the middle of the 14th century, an entirely different type of incised ware was introduced in Egypt, which is simply known as **"Mamluk sgraffiato".** Its introduction coincides with the stylistic changes in pottery and metalwork, when figural decoration becomes secondary to heraldic designs and inscriptions. The inscriptions are written in the so-called "Mamluk *naskh*" style. Mamluk *sgraffiato* was made of heavily potted red earthenware, then coated with a comparatively thick slip which is often coloured in yellow. The incised patterns were frequently painted in manganese. The largest collection of Mamluk *sgraffiato* pottery is in the Museum of Islamic Art in Cairo. Very few museums in the western hemisphere possess such vessels. There are several such complete vessels and fragments in the Tareq Rajab Museum, among them a hemispherical bowl with everted almost flat rim, which recalls the shape of Syrian pottery vessels and also the influence of contemporary metal bowls (**no. 44**). Inside the well displays a hexagonal star, a frequently used pattern in Islamic art. There are four swimming fish around. The rim carries pseudo-Kufic inscriptions. It is rather rare to see Kufic inscriptions on this type of pottery, but it may be an indication of an early date. The second specimen, a bowl with slightly everted rim, is covered on both sides with a brown ground slip into which the modest decoration, an inscription was incised (**no. 45**). The inscription reads: *"al-iqbal al-....."*, "prosperity, the...."

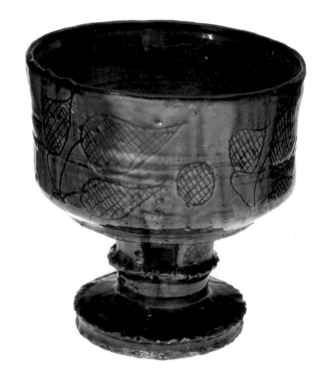

43. Cup bowl, simple *sgraffiato*, coated with a green glaze. *Egypt, Mamluk period, late 13th - early 14th century AD.*

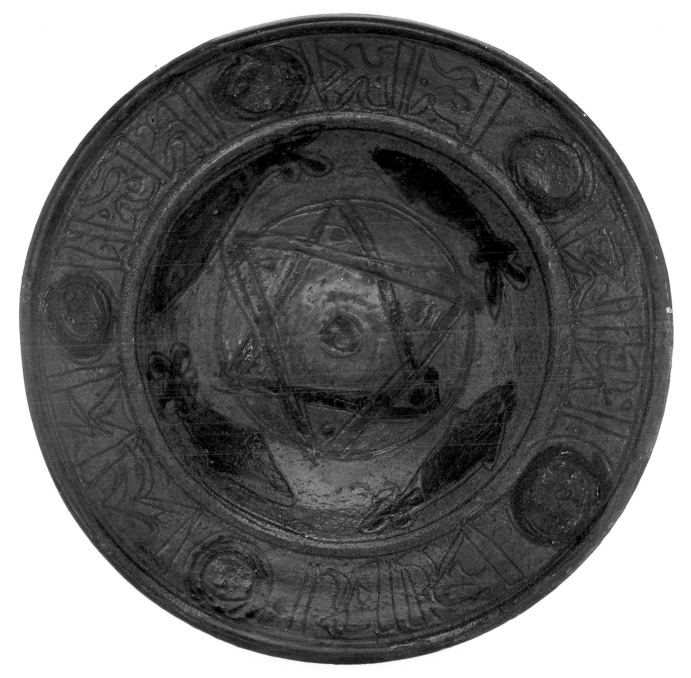

44. **Bowl,** Mamluk *sgraffiato* with a hexagonal star and four swimming fish around and pseudo-Kufic inscription on the rim. *Egypt, Mamluk period, 14th century AD.*

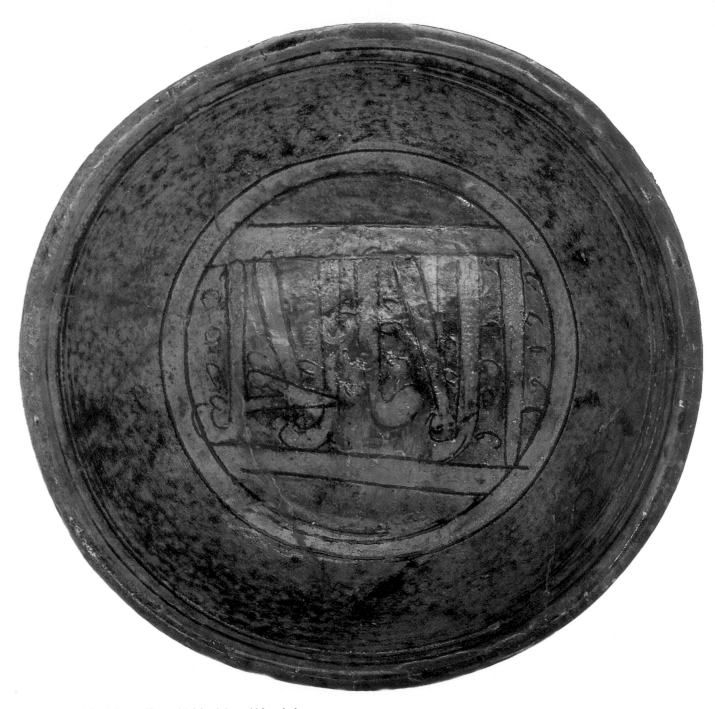

45. Bowl, Mamluk *sgraffiato*, with Mamluk *naskh* inscription.
Syria, Mamluk period, 14th - 15th century AD.

46. **Rectangular tile,** monochrome glazed. It was most likely part of a large wall panel decoration either in a religious or in a secular building. Iran, Ilkhanid period, dated 684AH/AD1285.

6. ILKHANIDS AND TIMURIDS

Recovery from the Mongol devastation was slow and did not begin until they settled down, embraced Islam and established the Ilkhanid dynasty (654AH/AD 1256 - 754AH/AD1353). With the Mongols came a strong Far Eastern influence and this was clearly visible in every art media. Shapes of pottery vessels and their decoration reveal the influence of Chinese art. Most of the earlier pottery centres, like Gurgan, Nishapur and Rayy were destroyed, but Kashan survived and production continued after a few years of lull. **Monochrome-glazed**, lustre and underglaze-painted vessels and tiles were still made there, like e.g. the rectangular tile which bears a date (**no. 46**). It was probably part of a large panel, decorating a mosque or perhaps a palace. At the same time new production centres emerged, like Arak and several villages in its region. It was most likely there where the so-called **"Sultanabad" pottery** was produced. There were three types of these "Sultanabad" wares: the first one was coated with a grey ground slip, the designs were moulded and reserved in white with black outlines (**no. 47A-B**). The second type was painted in two colours, in black and cobalt-blue, although occasionally a third one, namely turquoise, may have been added. Some of the "Sultanabad" bowls had an entirely new shape. The rounded sides terminated on top in an everted and inverted flat rim (**no. 48**). That was a type of vessel which most likely originated in Syria. The third type were bowls with round flaring sides painted in two or three colours under a clear glaze and the majority of them were decorated with wedge-shaped panels (**no. 49**). They were most likely made at Kashan and also in Kirman province.

Like the monochrome-glazed and underglaze-painted wares, **lustre-painted** pottery has also changed in style, in the colour of their pigments and in the shape

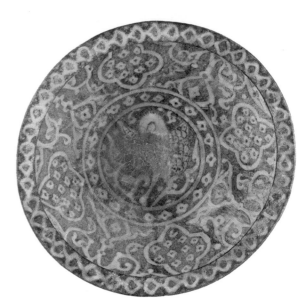

47A Large bowl, underglaze-painted, so-called "Sultanabad" ware. *Iran, probably Arak region, Ilkhanid period, dated: 716AH/1316AD.*

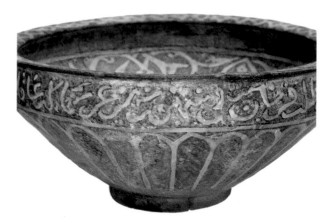

47B Large bowl, underglaze-painted, so-called "Sultanabad" ware. *Iran, probably Arak region, Ilkhanid period, dated: 716AH/1316AD.*

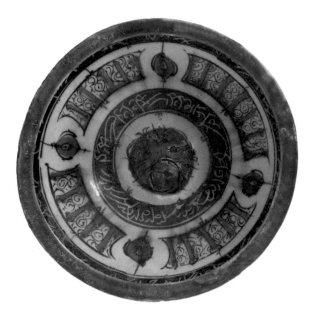

48. **Bowl,** underglaze-painted, so-called "Sultanabad" ware.
Iran, probably Arak region, Ilkhanid period, 13th - early 14th century AD.

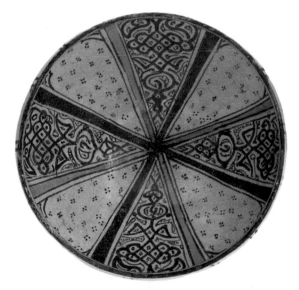

49. **Large bowl,** underglaze-painted ware.
Iran, probably Kashan or Kirman Province, Ilkhanid period, late 13th - early 14th century AD.

of vessels. A lustre and cobalt-blue painted bowl (**no. 50**) in the Tareq Rajab Museum is an excellent example to demonstrate the changes: it has rounded flaring sides, but rests on a widely splayed foot-ring, which is a borrowing from contemporary metal vessels; the colour of the lustre is darker, more brownish, not so shiny as on earlier objects and the decoration is overcrowded showing a shoal of swimming fish.

Large number of lustre-painted tiles were made in Kashan during the Ilkhanid period. Several of these were used for the decoration of *mihrabs,* or prayer-niches. Many of these were large panels, while others were small star-shaped, hexagonal or simply square or rectangular ones. Of the large lustre-painted *mihrabs* a few still survives *in situ.* Here it is perhaps worthwhile to mention an interesting *mihrab* in Iran which is made-up of numerous monochrome-glazed, star-shaped and hexagonal lustre-painted tiles (**plate I**). It is in a mosque called *Masjid-i Ali,* in a small village called Qohrud, half way between Kashan and Natanz. The *mihrab* recess is rectangular. The walls of the recess and even part of the *qibla* wall are decorated with green-glazed and lustre-painted tiles, several of which are dated respectively to 700AH/AD1300 and 707AH/ AD1307. At the back of the recess there is a rectangular green glazed *mihrab* tile, similar to the Tareq Rajab Museum's example, bearing the date of 707AH/AD1307, while above, horizontally placed, is a foundation inscription, giving the date of completion of the mosque as 736AH/AD1335.

The most obvious and striking change was in the treatment of overglaze-painted, the so-called *mina'i* vessels. The palette of the colours was limited and the decorative themes more restricted. Instead of the "seven" colours only black, white and red were used with additional gilding. Some of the designs were in relief, or even in openwork. The glaze became light

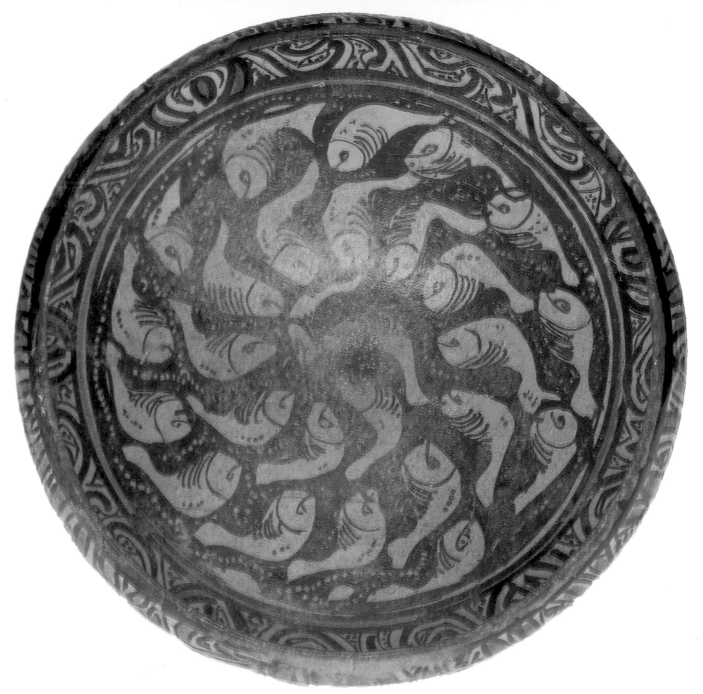

50. **Bowl,** lustre and cobalt-blue painted. The darker shade of the lustre and the over-crowded decoration are characteristical of the Mongol period.
Iran, probably Kashan, Ilkhanid period, 13th - early 14th century AD.

Plate I - *Mihrab* **of the Masjid-i Ali in Qohrud.** Decorated with monochrome-glazed and lustre-painted tiles. (Photo Géza Fehérvári)

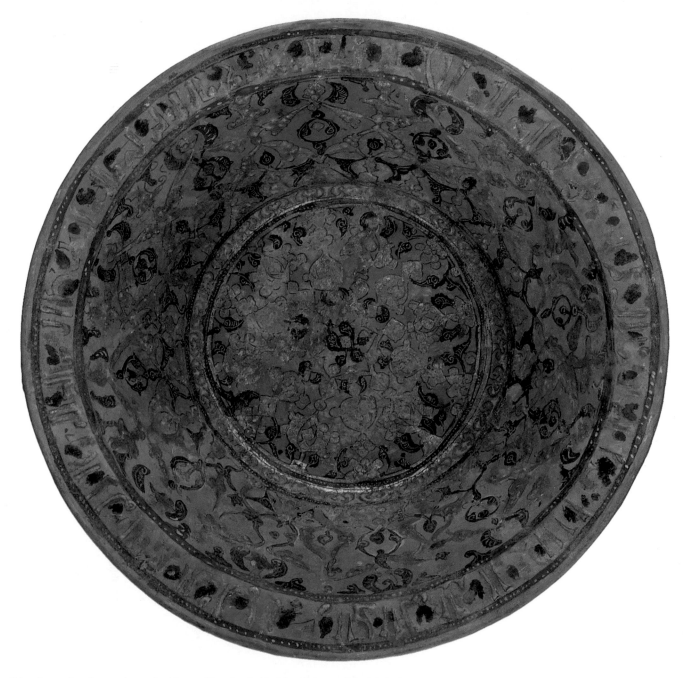

51. Large bowl, overglaze-painted, transitional *mina'i - lajvardina* ware. Moulded, gilt and painted in black and white over a light blue glaze. *Iran, Kashan, Ilkhanid period, mid-13th century AD.*

52. **Tile**, overglaze-painted, so-called *lajvardina* ware. Similar *lajvardina* tiles decorated the walls of the Ilkhanid ruler Abaqa Khan in Takht-e-Sulayman in north-west Iran.
Iran, Ilkhanid period, 13th - early 14th century AD.

53. **Bowl**, underglaze painted ware.
Iran, Timurid period, late 14th - early 15th century AD.

54. **Bowl**, underglaze painted ware.
Iran, Timurid period, late 14th - early 15th century AD.

blue. A large bowl in the Museum is decorated with moulded arabesques and pseudo-Kufic inscriptions, painted in red, white and black and partially gilt, over a light turquoise-blue glaze (**no. 51**). This type of overglaze-painting may be regarded as transitional to the later, the so-called *lajvardina* technique which was developed towards the end of the 13th century. The term derives from the Persian word *lajvard*, meaning "cobalt-blue", since the vessels and tiles were coated with a cobalt-blue glaze and the decoration was painted in black, white and red, while the gold was cut out from thin gold leaves and glued to the top of the designs (**no. 52**).

Lajvardina tiles decorated the walls of the palace of the Ilkhanid Sultan, Abaqa Khan (663AH/AD1265 - 680AH/1282AD) at Takht-e-Sulayman in north-western Iran (**plates J and K**). The German excavations discovered not only tiles and tile fragments, but also the kilns where these tiles were made.

By the second half of the 14th century Kashan ceased to be a pottery centre. At the same time several new ones emerged, like Kirman and Meshhed. Simultaneously insignificant provincial ones also came into existence, among them **Varamin**. Varamin produced mainly large dishes, plates or bowls, decorated with floral designs and crosshatchings, painted in blue, black and turquoise under a clear glaze. These wares are well represented in the Tareq Rajab Museum and the two bowls illustrated here are typical examples (**nos. 53 and 54**).

One of the new types of wares which were introduced in late Timurid times was the blue and white. As in Syria, the inspiration came from contemporary Chinese blue and white porcelain, as can clearly be seen on some of the earlier vessels. The Museum's Timurid jar represents a rare and unique type (**no. 55**). It has a cylindrical body with a decoration that was painted in two shades of blue. There are two floral scrolls issuing from centrally placed rosettes. There is the signature of the artist at the base: *Laqa Baba*, whose identity is unfortunately not known.

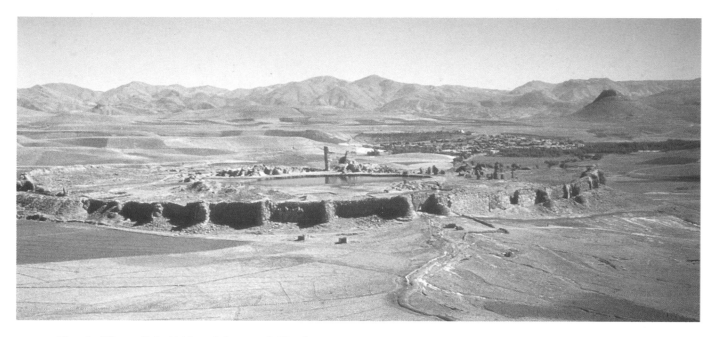

Plate J - Views of the Takht-e Sulayman, in Northwestern Iran. The remains of Abaqa Khan's palace are visible behind the lake. (Photo Géza Fehérvári)

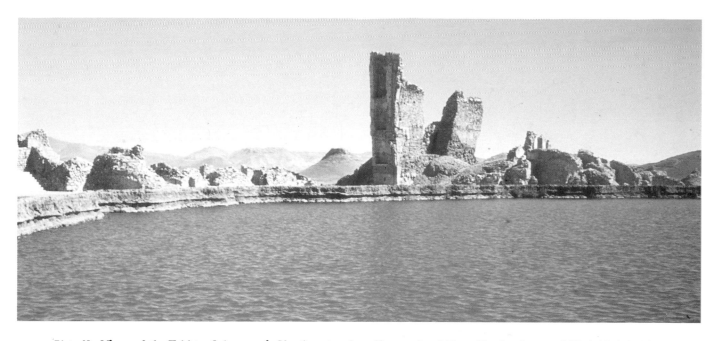

Plate K - Views of the Takht-e Sulayman, in Northwestern Iran. The remains of Abaqa Khan's palace are visible behind the lake. (Photo Géza Fehérvári)

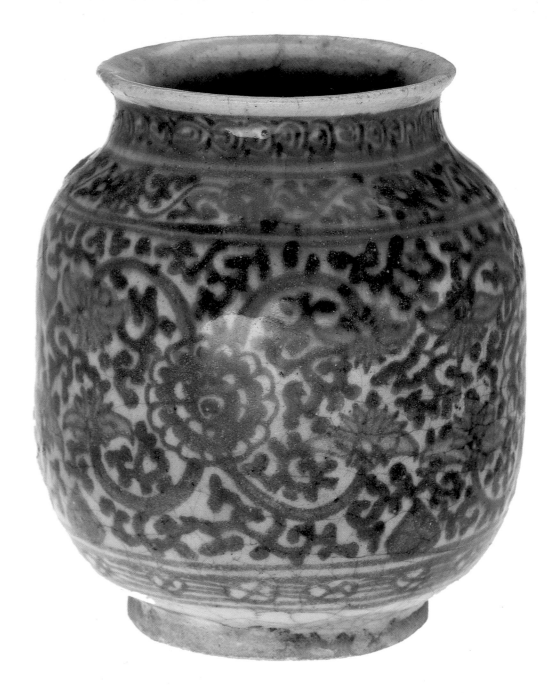

55. **Jar**, blue and white ware. This jar with its dense floral decoration belongs to the earliest examples of the Iranian blue and white pottery. *Iran, Timurid period, late 15th century AD.*

68

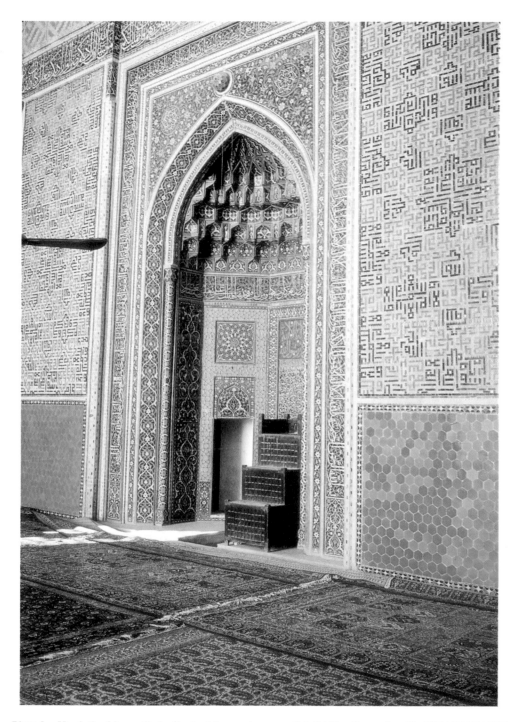

Plate L - Yezd, the faience tiled mihrab of the great mosque (Masjid-i Jami) completed in 777AH/AD1375. (Photo Géza Fehérvári)

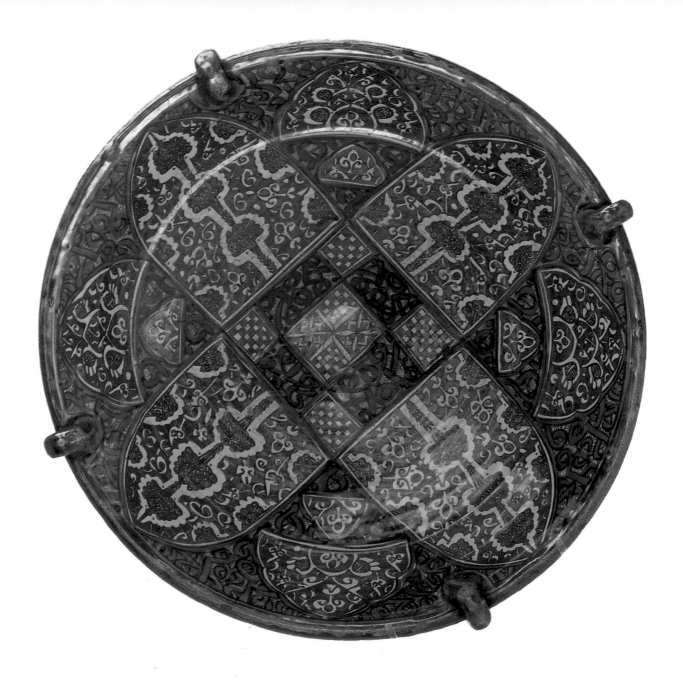

56. Large bowl, so-called "Hispano-Moresque" ware. The shape of this vessel, the combination of lustre and cobalt-blue colours and the style of its decoration, reveal the hands of Malagan potters of the late 14th or early 15th centuries.
Spain, Malaga, ca. 1400AD.

70

7. "THE MAGHRIB" - SPAIN AND NORTH AFRICA

Lustre-painted pottery was produced in Spain towards the end of the Muslim rule, during the late 14th century. The earliest and perhaps one of the most important pottery centres was at Malaga. The Museum's large bowl is an early product of Malaga (**no. 56**). It was at Malaga where such large and deep bowls were made. They rest on strong foot-rings and most of them have rope-like handles attached to the rims. All known vessels are painted in brownish-yellow lustre and cobalt-blue. The reverse of this large bowl bears all the hallmarks of the Malagan workshops.

After the fall of Granada and the fall of the Nasrid dynasty in 897AH/AD1492, production at Malaga and at other Andalusian centres came to a halt. It continued further north at Valencia, Manises, Paterna and Reus. The shape of the vessels changed, with more rounded or spherical bowls also being made, likewise jars, or *albarelli*, two handled jugs and tiles. Moorish patterns were replaced by European coat of-arms, ships, animals or birds, even human figures were depicted. The jar, or *albarello*, with a cylindrical body and sloping shoulder has a yellowish-green lustre and cobalt-blue painted decoration over an opaque white tin glaze (**no. 57**). It was probably made at Manises or perhaps Valencia in the late 15th or early 16th century.

Very little is known about early Islamic pottery of North Africa, particularly of Morocco. What is known of later pottery production in Morocco is that it received new impetus after the fall of Granada, when large number of Muslim artists and craftsmen were expelled from Spain. From early Islamic times onwards, one of the most important pottery centres was Fes, while others were at Meknes and Safi. From the late 17th century onwards, more information and more objects are available. The Tareq Rajab Museum's

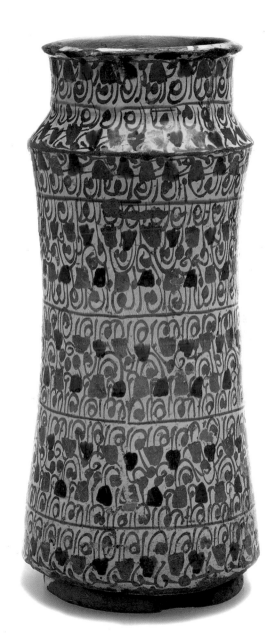

57. **Albarello**, so-called "Hispano-Moresque" ware, painted in lustre and cobalt-blue.
Spain, late 15th or early 16th century AD.

71

58. **Inkwell,** in the shape of a four-petalled flower, with openwork decoration, coated with dark cobalt-blue glaze.
Morocco, 18th - 19th century AD.

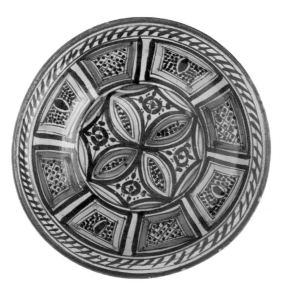

Moroccan pottery date mainly from the 18th and 19th centuries. One of the most interesting and perhaps earliest item is an inkwell in the shape of a four-petalled flower and completely covered with a dark cobalt-blue glaze (**no. 58**).

Polychrome painted wares were and still are much more common in Morocco. Most of them were made by the craftsmen of Fes. One of the most popular vessels are deep and large bowls and dishes. The vessels are made of buff earthenware and the majority of them are coated with a yellow or white ground slip on which the designs were painted in blue, green and black. Black, however, plays only a secondary role.

59. **Large dish,** painted in black, blue and green over a yellow ground slip.
Morocco, probably Fes, early 19th century AD.

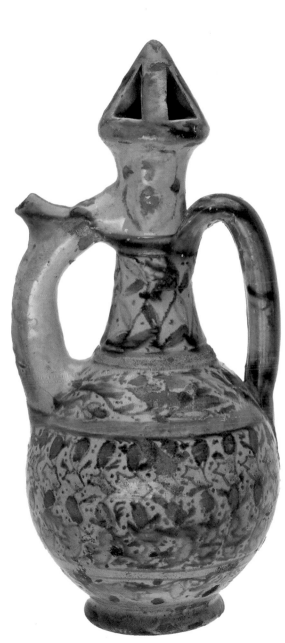

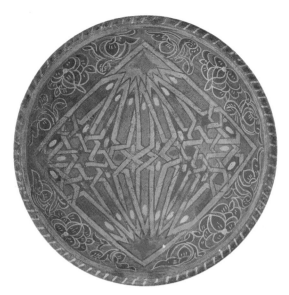

61. **Large dish**, painted in polychrome with floral and geometrical patterns.
Morocco, second half of the 19th century AD.

60. Ewer, painted in green, blue, yellow and black.
Morocco, probably Fez, early 19th century AD.

The decorations combine floral and geometrical patterns in a style that was typical of the kilns of Fes (**no. 59**). Another interesting shape is the ewer which has a fixed conical top with triangular openings (**no. 60**). It is provided with two handles, but in fact one of them serves as a spout. Both of these vessels may be attributed to the early 19th century. An intriguing piece is a polychrome painted large and comparatively heavy dish on which red is the dominant colour (**no. 61**). It serves as a background for the yellow painted geometrical patterns, all outlined in black, set within a square. The areas beyond the square are filled by blue painted floral motifs outlined in white. This large dish may be dated to the second half of the 19th century.

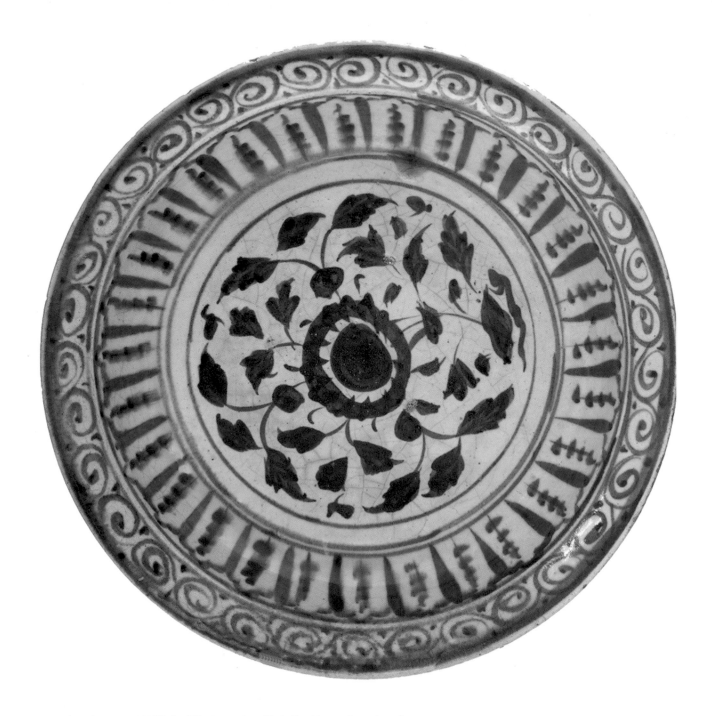

63. **Large dish,** so-called "Kubachi" ware, painted in indigo blue under a clear glaze.
Iran, Safavid period, early 16th century AD.

8. POTTERY OF THE SAFAVID AND QAJAR PERIODS IN IRAN

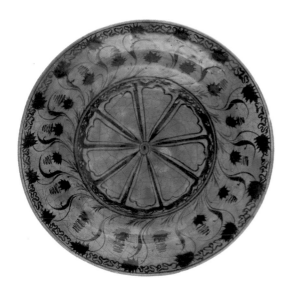

63. **Large dish,** so-called "Kubachi" ware, painted in black under a blue glaze.
Iran, Safavid period, late 16th century AD.

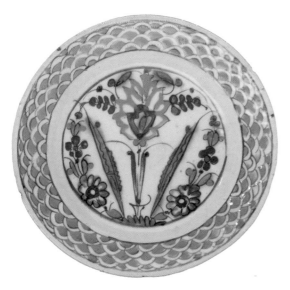

64. **Small dish,** so-called "Kubachi" ware, painted in polychrome under a clear glaze.
Iran, Safavid period, early 17th century AD.

The Safavids originally came from Azerbaijan in north-western Iran. Their first ruler, Isma'il, seized power in 907AH/AD1501 and nine years later occupied Herat, and thus inherited the Timurid Empire. At the beginning their capital was at Tabriz, but because of the constant Ottoman threat they moved it first to Qazvin and then Shah Abbas I (996AH/AD1588-1038AH/ AD1629), the most outstanding person of the dynasty, relocated it to Isfahan. For arts and culture the rise of the Safavid dynasty was the beginning of a new golden era. In spite of their Turkish origin, they became Persian patriots and patrons of the arts. This new spirit was particularly noticeable in pottery. From the beginning of the 16th century, right through the Qajar period to the end of the 19th, large number of interesting pottery types were developed and produced. They may be divided into the following main groups: the so-called "Kubachi" wares, celadon imitations, blue and white Kirman polychrome, late lustre, the so-called "Gombroon" wares and Qajar polychrome pottery and tiles.

The name "Kubachi" comes from a small town in Daghestan in the Caucasus, where this type of pottery was discovered during the last century, decorating the walls of peasant houses. The problem is that Kubachi never produced pottery, but they were excellent metalworkers and armourers, makers of richly decorated daggers and swords. It is possible therefore, that they exchanged their products for the beautiful pottery dishes. There are several types of these "Kubachi" pottery. One of them is painted in black under a blue or green glaze, decorated with floral designs, like a large dish in the Tareq Rajab Museum which may be dated to the late 16th century (**no. 62**). Vessels of the second type were painted in indigo blue, presenting scrollworks and flowers, occasionally swimming fish or birds (**no. 63**). They

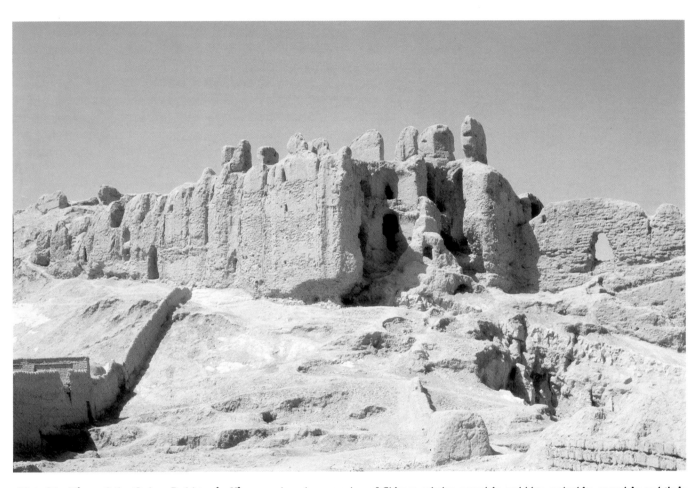

Plate M - View of the Qala-e Dukhtar in Kirman, where large number of Chinese celadon porcelain and blue and white porcelain and their local imitations were discovered. (Photo Géza Fehérvári)

from the late 15th century up to the end of the 16th. The third type, which was introduced slightly later, was painted in polychrome. The decoration frequently presents the portraits of young ladies or men, or floral landscapes (**no. 64**).

Chinese celadon, just as blue and white, was always admired and in great demand in the Islamic world. This admiration for Chinese celadon had inspired the potters of Iran as early as the latter part of the Ilkhanid and early Timurid periods to produce imitations. Indeed such vessels were made, but the early examples were far from acceptable as "celadon imitations". It was in the late Timurid and early Safavid times that the Iranian celadon imitations approached and almost reached the quality of the Chinese prototypes. Both in shape, colour and weight they come close to the Chinese originals. There are original Chinese celadon dishes in the Museum, dating from the late 14th or early 15th century and also their Iranian imitation, like the large dish with fluted sides and everted sloping rim (**no. 65**).

Blue and white wares gained more importance during the Safavid period. By then there were three major pottery centres in Iran, where such vessels were manufactured: Meshhed, Yezd and Kirman (**plate M**). Vessels of Meshhed were made of very fine and thin white faience and the decorations were painted in two shades of blue. Dishes, bowls and plates imitate Chinese porcelain equivalent and their decorations copy Chinese figures, landscapes and Buddhist symbols as we can observe them on the Tareq Rajab Museum's large bowl (**no. 66**). The second Meshhed ware in the Museum is a spittoon. Strictly speaking it is not a blue and white ware, since black was used for outlining the designs (**no. 67**). Nevertheless its shape, but particularly its decoration reveals its close relationship to the proper blue and white vessels. The body is decorated with two large bushes and two flying birds, probably storks. On the upper part there are

intertwined scrolls and lotus petals on the neck. The base carries a pseudo-Chinese tassel mark.

The Safavid period witnessed the introduction of a new type of underglaze-painted decoration in polychrome. The majority of these vessels show an interesting combination of blue and white designs with brownish-red and green or yellowish-green. Arabesques, floral patterns and human figures are depicted. This underglaze polychrome ware was produced in Kirman during the 16th to early 18th centuries. The polychrome painted dish in the Museum is decorated with a bouquet of brownish-red painted feathery leaves, surrounded by cobalt-blue painted floral scrolls (**no. 68**). The ovoid panels on the rim are filled by pseudo inscriptions.

Lustre-painting, which lost its eminent position after the 14th century, came into the lime-light again in Safavid times. The colours of Safavid lustre vary from chocolate-brown to copper-red, while in Qajar times it becomes almost pinkish. Safavid lustre wares appeared sometimes towards the end of the Safavid period and from then on they were produced continuously until the present day. The place of production is not known. A very fine Safavid lustre vessel in the Tareq Rajab Museum is a ewer, outside coated with a cobalt-blue glaze over which the decoration of blossoming flowers appear in a silvery colour (**no. 69**).

Perhaps one of the finest wares, not only of the Safavid period, but of pottery in general that was ever produced in Iran, is the so-called "Gombroon" ware. Its very fine and thin faience body, particularly with its openwork decoration, comes very close to Chinese porcelain. The name "Gombroon" comes from the port in the southern part of the Iranian side of the Gulf whence these wares were shipped to Europe by the British and Dutch East India Companies.

65. **Large dish**, celadon imitation. Islamic potters began to imitate Chinese celadon porcelain as early as the 14th century, but did not fully succeed until the Safavid period. This large dish is a faithful imitation of the Chinese prototypes, not only in colour and shape, but also in its weight.
Iran, probably Kirman, Safavid period, 17th century AD.

Gombroon was the name of modern Bandar Abbas, now called Bandar Khomaini. The "Gombroon" ware bowl in the Museum was made of hard and thin white faience body with elaborate pierced decoration, showing a series of floral motifs (**no. 70**).

By the end of the 18th century, pottery production centred mainly in Isfahan and Tehran which became the capital of the Qajar dynasty (1212AH/AD1797 - 1342AH/1924AD. That does not suggest that other centres, like Shiraz, Natanz, Tebriz and Hamadan were not as important. The finer and more important vessels and tiles, however, were made in Isfahan and, by the mid-19th century in Tehran. The *kalian*, or water pipe base may be the product of the workshops of Isfahan (**no. 71**). Its shape follows those of the earlier Safavid period products, but the decoration is now dominated by Qajar style of flowers. From the Timurid period onward tile work, particularly mosaic faience, played a significant role in architectural decoration. By the Safavid period the technique was simplified by the introduction of painted tiles. Their popularity has much increased in Qajar times when not only religious or public buildings, but private homes were decorated with tiles. There are several interesting Qajar tiles in the Museum, among them a mihrab tile which, according to its inscription, was made in Tehran by *"master Agha Khan"* during the second half of the 19th century (**no. 72**).

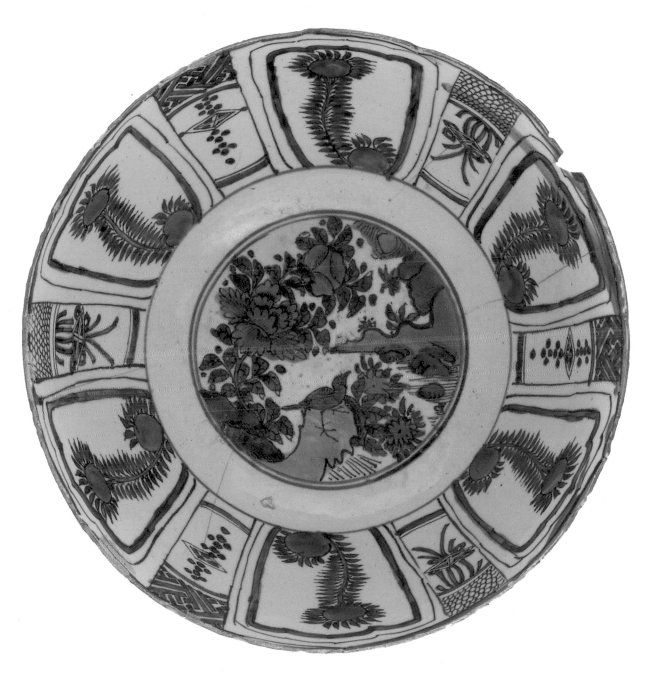

66. Large bowl, blue and white ware. The decoration of this large bowl may have been faithfully copied from a Chinese blue and white porcelain vessel.
Iran, Meshhed, Safavid period, 17th century AD.

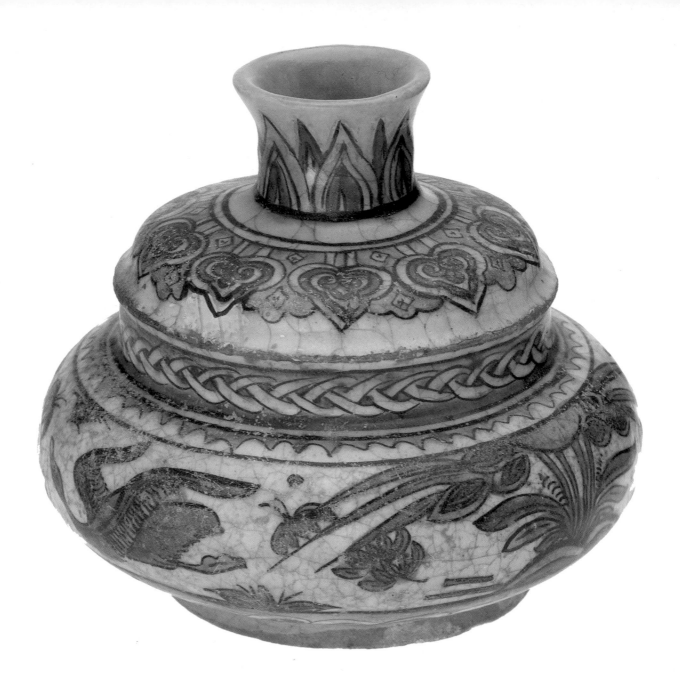

67. **Spitoon**, blue, black and white ware. Although this is not entirely a blue and white ware, but its shape and decoration reveals that it was made by the same potters and in the same workshop, where so many similar blue and white painted spitoons were produced.
Iran, Meshhed, early 17th century AD.

68. Dish, so-called "Kirman polychrome" ware. It was in Kirman, during the Safavid period, where the blue and white and brownish-red painting was successfully combined under a clear glaze.
Iran, Kirman, Safavid period, 17th century AD.

69. Ewer, painted in lustre over cobalt-blue glaze. The practice of painting lustre over a cobalt-blue glaze was already introduced during the 12th and 13th centuries, but then it was forgotten. It became popular again towards the end of the Safavid period.
Iran, Safavid period, late 17th or early 18th century AD.

70. Bowl, so-called "Gombroon" ware with openwork decoration. This type of pottery was a successful attempt to imitate Chinese white porcelain. Although the name of the old port of "Gombroon" was given to this ware, it is more likely that they were made either in Isfahan or in Shiraz.
Iran, Safavid period, late 17th - early 18th century AD.

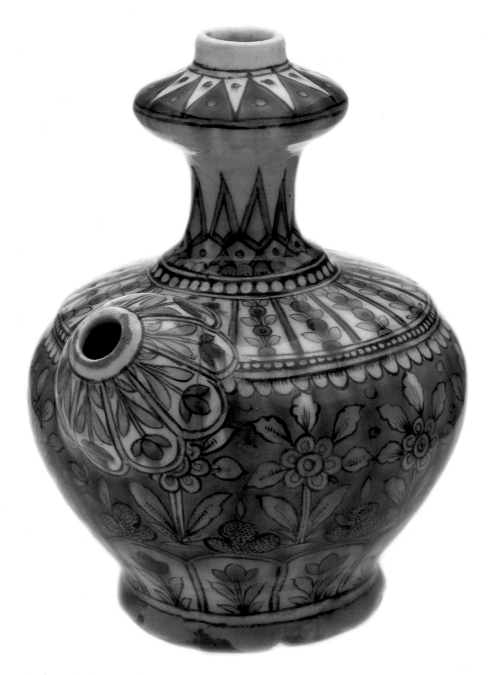

71. Kalian, or water pipe base, polychrome painted ware. This is a typical early Qajar period vessel and may have been made either in Isfahan or in Tehran.
Iran, Qajar period, 19th century AD.

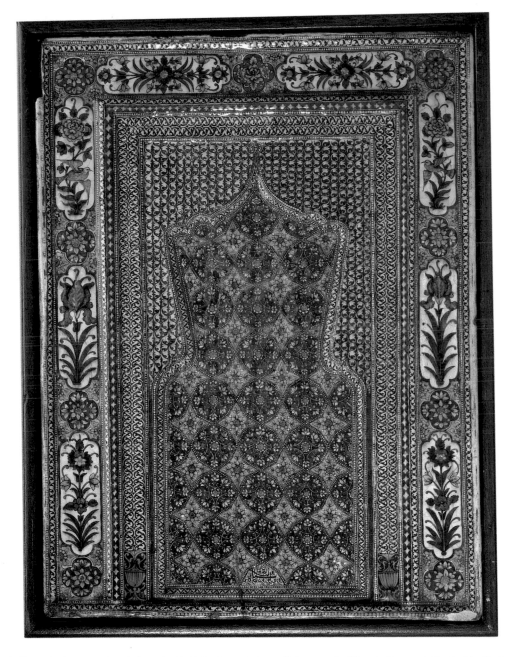

72. ***Mihrab* tile,** polychrome painted. Signed: *Made in the workshop of Master Agha Khan in Darwazeh Daulet"* (a district of Tehran). *Iran, Qajar period, 19th century AD.*

85

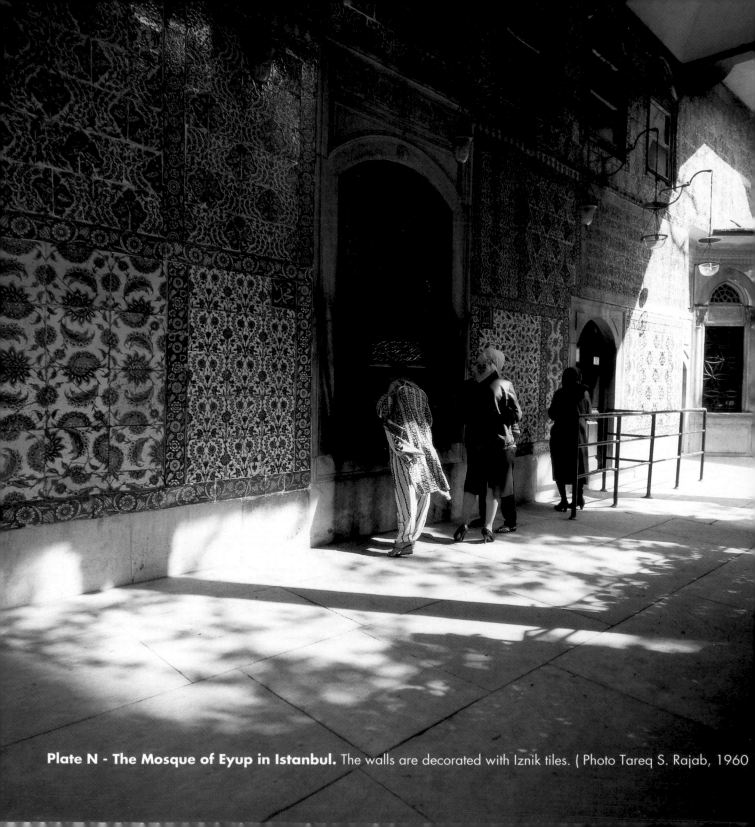

Plate N - The Mosque of Eyup in Istanbul. The walls are decorated with Iznik tiles. (Photo Tareq S. Rajab, 1960

9. OTTOMAN POTTERY OF ANATOLIA

The golden age of Ottoman pottery coincided with the apex of the Ottoman Empire and with the reign of Sultan Sulayman the Magnificent (926AH/AD1520 - 974AH/AD1566). The Sultan's large scale building activities were one of the most important driving forces behind the work of the potters of Iznik (cf. **plate N**). The inspiration most likely came through the hundreds of Chinese blue and white porcelain wares which were arriving at the Sublime Court in Constantinople. The major pottery centre was at Iznik, where as the archaeological works there have shown, red earthenware pottery, the so-called "Miletus" ware, was produced long before the introduction of its famous faience tiles and vessels. The "Miletus" wares were decorated mainly in underglaze blue painting. Suddenly, towards the end of the 15th century, these earlier earthenwares were replaced by beautiful faience tiles and vessels. There is a panel made-up of nine Iznik tiles in the Museum. These tiles are decorated in polychrome with extensive floral decoration (**no. 73**). Probably one of the earliest and perhaps the most outstanding examples among the Museum's Iznik wares is a large dish (**no. 74**). It is decorated in polychrome, depicting a centrally placed green painted cypress tree, flanked by red carnations and blue tulips. Another item is a dish, almost the same size and shape as the previous one, except that it has serrated edges and is painted only in cobalt-blue, green and black (**no. 75**). The absence of the sealing wax red and the somewhat reserved decoration could indicate an earlier date. However, it was pointed out recently by some scholars that it belongs to a later group , which they call "later blue and white, flower pot with rock design". The two-handled tankard with its globular body and tall slightly opening neck may belong to the last quarter of the 16th century (**no. 76**). It is painted in polychrome showing hyacinths and tulips and the rim is decorated

with a narrow band of black scrolls overpainted in green. Another major pottery centre in Anatolia was (and still is) Kūtahya. For a long time, it was believed that the rise of pottery production there was connected with the decline of Iznik towards the end of the 16th century. However, it has now been shown that Kūtahya produced pottery a long time before that. Nevertheless it is true, that when pottery production at Iznik came to an end, some of the potters settled at Kūtahya. From the early 18th century onwards, there are dated vessels and tiles, stating that they are the products of that town. Earlier vessels may have been in the style of Iznik, but the 18th century products were entirely different. By then, Kūtahya developed its own style, frequently imitating European porcelain and faience. Coffee and tea-cups and pots are un-mistakbaly European shaped. Others reproduce well-known Near Eastern metal shapes, like jugs and rose-water sprinklers. One of the rose-water sprinklers in the Tareq Rajab Museum has silver mount, with four armorial bearings on the shoulder (**no. 77**). Another vessel popular in Kūtahya is the pilgrim-flask, a type, as we have already seen, which was popular all over the Near and Middle East and in Europe since prehistoric times. The Museum's pilgrim-flask is made-up of two halves: one half, which may be regarded as the top, is slightly bulging and has a circular concave depression in the centre (**no. 78**). On top, two small handles are attached. The decoration is painted in blue, green, yellow and outlined in black. An interesting Kūtahya ware in the Museum's collection is a hanging ornament in an egg-shaped form (**no. 79**). There are three large oval-shaped sealing wax red painted medallions, each with an Arabic inscription in blue, written in cursive style. The inscriptions are in mirror style, i.e. they can be read from right and left. They read: *"Oh, my Dear [God], look at me with pity".*

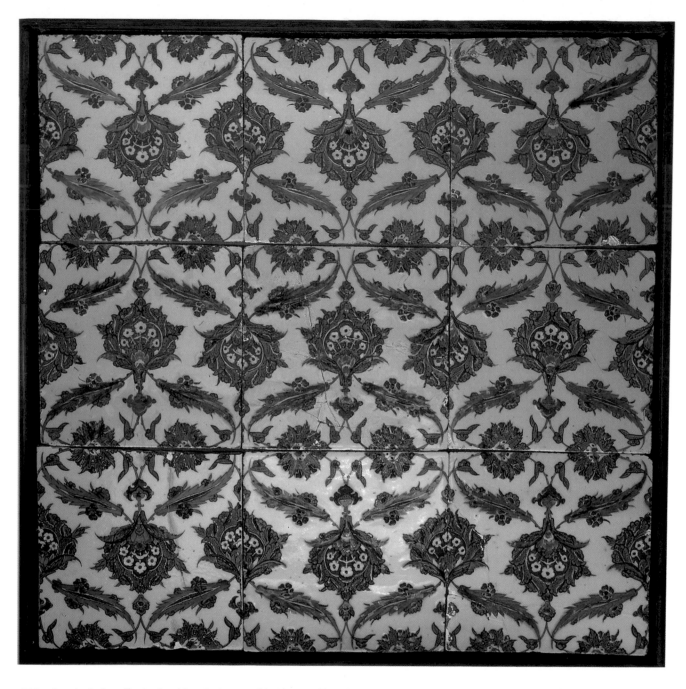

73. **Panel of nine tiles,** painted in polychrome with *hatay* motifs and *saz* leaves.
Turkey, Iznik, second half of the 16th century AD.

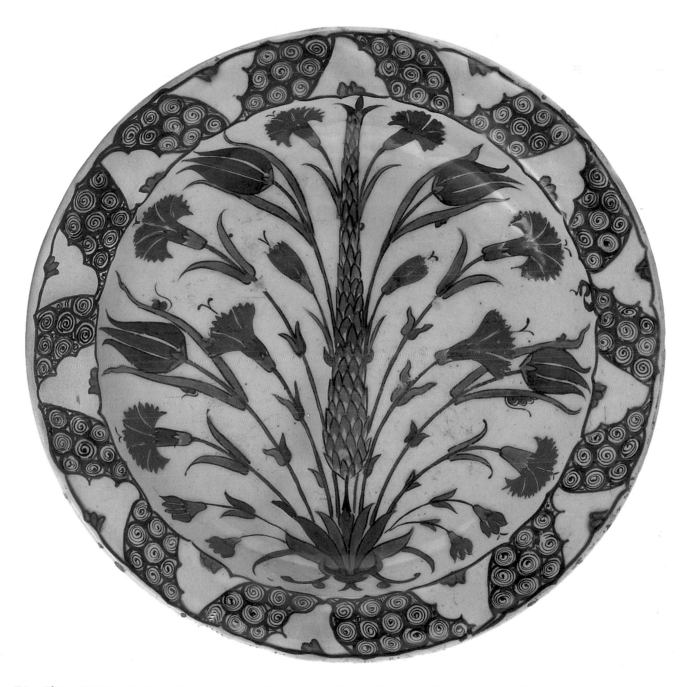

74. Dish, painted in polychrome. It may be called a "cypress tree" dish combined with tulips and carnations. It was a typical design during the last years Sultan Sulayman the Magnificent and his successor, Selim II's reigns.
Turkey, Iznik, ca. 1560 - 75.

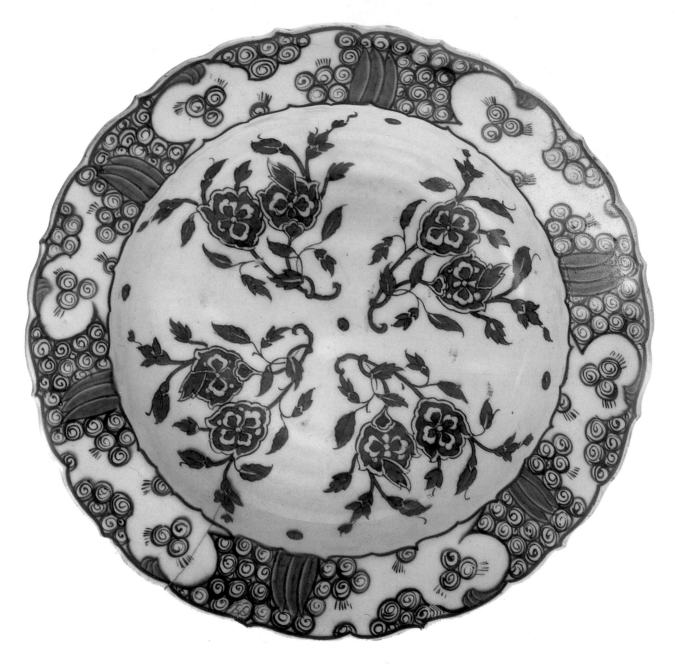

75. Large dish, painted in blue, black and green. The absence of the sealing wax, red may indicate an early period, it was, however, pointed out quite recently, that the decoration, with the flower pots and rocks was produced under a later Chinese influence.
Turkey, Iznik, ca. 1570 - 80.

76. Tankard, painted in polychrome. The shape and decoration of this vessel indicates a late 16th century date.
Turkey, Iznik, ca. 1580 - 90.

91

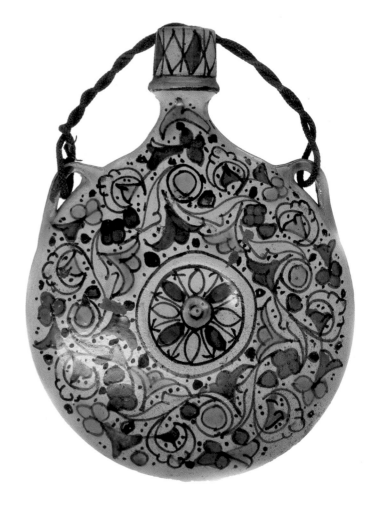

77. **Rose-water sprinkler,** with silver mount, painted in polychrome.
Turkey, Kutahya, 18th century AD.

78. **Pilgrim flask,** painted in polychrome.
Turkey, Kutahya, 18th century AD.

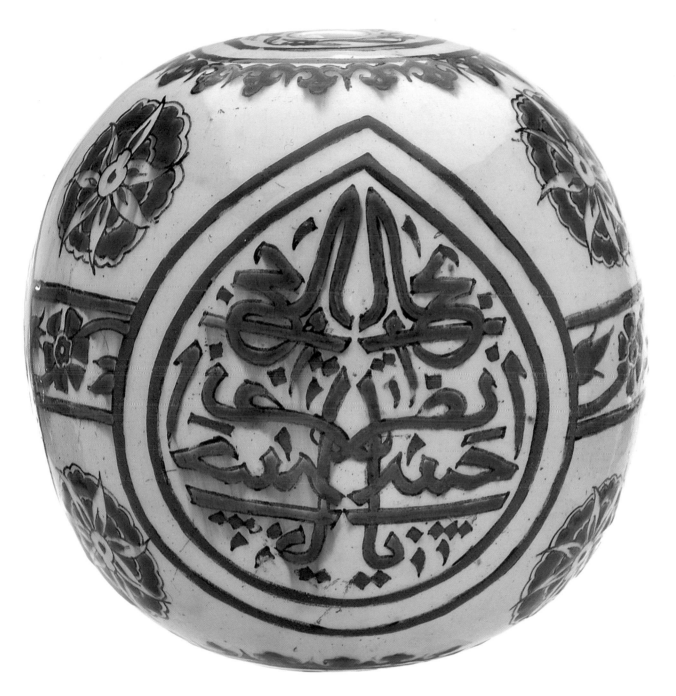

79. Hanging ornament, painted in polychrome.
Turkey, Kutahya, 18th century AD.

10. UNGLAZED POTTERY (POTTERY MOULDS, CASTS AND A POTTER)

On every archaeological site, the majority of the excavated pottery is always unglazed (**plate O**). This is not surprising, since almost every village community produced its own simple common ware, while the sophisticated glazed pottery was manufactured only in major centres. Because these unglazed wares appear in large numbers and the communities borrowed shapes, designs and techniques from each other which have survived and continued for centuries, it is not an easy task either to date or to determine the actual provenance of these vessels.

The Tareq Rajab Museum's unglazed pottery collection includes examples from almost every part of the Islamic world. Some of these are pre-Islamic, like e.g. a spherical bodied jar, made of red earthenware and decorated with *appliqué* and moulded designs (**no. 80**). The body carries two identical decorative registers showing continuous undulating floral scrolls over a ring-matted background. They are bordered by pearl motifs. Between these two registers and on the shoulder are narrow bands of *appliqué* buttons, each with a star motif. These are very common on late Sasanian or early Islamic glazed vessels. The short neck and the everted rolled rim is also typical on Sasano-Islamic pottery.

The small unglazed jug with black painted decoration has a globular and symmetrical body which indicates that it was made on a potter's wheel (**no. 81**). The painted decoration covers the upper part of the vessel, including the interior of the rim. The design of wavy lines and circles recall some of Umayyad jugs and jars which were excavated in the Citadel of Amman and some other Umayyad sites in Jordan. The unglazed pottery-lamp with its refined scroll decoration presenting undulating floral scrolls (**no. 82**) recalls similar examples which were excavated at an early Byzantine basilica in Palestine. But there are also glazed versions of this type in the Benaki Museum, Athens and in the Dar al-Athar al-Islamiyya in Kuwait, both dated to the period before the 9th century.

There is an interesting unglazed ewer in the collection decorated with extensive black painting. The globular body was made-up of two halves; the short neck continues on one side with tall, almost vertical upward pointing spout, the tope of which is missing; opposite there is a small handle attached and the mouth has a filter inside (**no. 83**). Five large semicircles decorate the body with a stylised fish underneath, crosshatchings and birds on the shoulder and inside the spout a serpent and a fish. The shape and the decoration indicates a Central Asian origin for this vessel and a date between the 10th and early 13th centuries.

The unglazed bottle reveal strong Fatimid period characteristics. It is made of greyish-green earthenware with carved and stamped decoration (**no. 84**). The globular body carries a wide decorative band which is divided into four irregular rectangles by vertical columns, each decorated with a peacock whose body and tail are embellished with dense small circles on a ring-matted background. The peacocks recall similar representations on Fatimid lustre-painted pottery, but perhaps the closest parallels are on North African, probably Tunisian polychrome in-glaze painted bowls which are dated to the 11th century.

A large jug made of a yellowish earthenware with extensive moulded, carved and incised decoration was most likely made in north-eastern Iran, in Khurasan, or in Afghanistan during the 10th to 12th centuries (**no. 85**). The globular body was made-up of two parts, it has a cylindrical slightly opening neck to which two hooks are attached, one with a freely moving ring and

a straight handle. The upper part of the body carries a deeply moulded and carved decorative band, showing intertwined scrolls which alternately form circles and lozenges, decorated with four-petalled flowers and palmettes on ring-matted background. Another Iranian or Central Asian vessel is the large pilgrim-flask (**no. 86**). It was made of yellowish-white earthenware in two halves. The lower one is hemispherical with a raised flat base, while the upper half is slightly rounded. At one side there is a rising spout, flanked by two large handles. Normally only the top part is decorated, but in this instance both reveal moulded decoration. Nevertheless the craftsman concentrated his attention on the ornamentation of the top which is more readily visible. Excavated comparative material indicates a date between the 12th to 14th centuries for this vessel.

The unusual circular black painted vessel was probably a container, or holder of spices (**no. 87**). The body opens upwards and rests on a splayed foot-ring. Inside it is divided into two halves, thus forming two separate holders. Each side is partly covered by a triangular top and, at the edge of one of these, a bird, probably a cockerel sits. The side and the top have black painted decorations, showing scrollworks and crosshatchings. This rare vessel in its rough finish and manganese painted decoration belongs to the group of unglazed painted wares which were made in Greater Syria during the late Ayyubid and early Mamluk periods. A somewhat similar rectangular container was excavated at Hama and dated to the Mamluk period.

There are some seventy moulds in the Tareq Rajab Museum's collection which were used for shaping pottery vessels. Most of them are made of red or buff earthenware and those which were used for moulding the interior of a vessel have a vertical join which was used as a handle. One of these moulds was made for shaping the exterior of an early Islamic lead-glazed

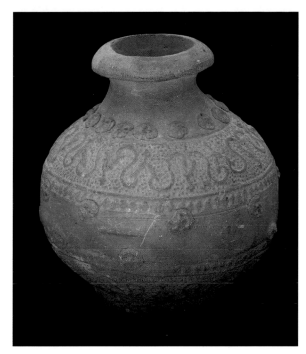

80. Jar, red earthenware with moulded and appliqué decoration. *Iran, Sasano - Islamic, 6th - 8th century AD.*

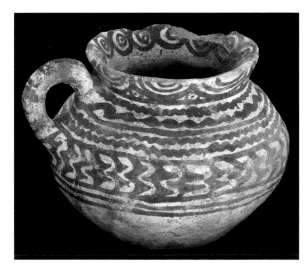

81. Jug, unglazed, painted ware. *Syria, Umayyad period, 7th - 8th century AD.*

95

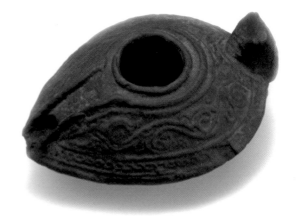

82. Pottery-lamp, moulded, unglazed ware.
Syria, Umayyad period, 7th - 8th century AD.

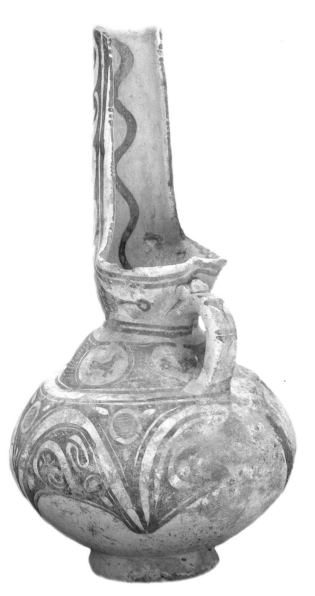

83. Ewer, unglazed, painted.
Central Asia, 10th century AD.

relief bowls (**no. 88**). It shows a large Kufic inscription. The style of the script is typical of the 3rd AH/AD 9th century. The dotted ground, together with the series of pearl motifs on the rim are characteristic of this type of vessel.

Another mould was used for the internal decoration of a bowl, showing intricate floral scrollwork at the base and plaited Kufic characters over dense scrollwork below the rim (**no. 89**). This was probably a master mould, since the edges of the carvings are very sharp. Inside it has a vertical join to be used as a handle.

There are also a few original casts in the Museum which, for some unknown reasons, were never completed. One of these casts is decorated with two undulating scrolls which form series of roundels, each decorated by a cursive script. One of these bears the signature of the artist, reading: *"amala Mahmud"* (**no. 90**).

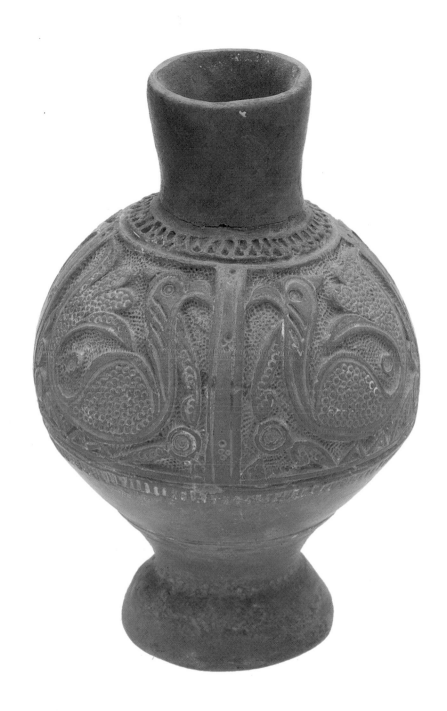

84. **Bottle,** unglazed ware with carved and moulded decoration, showing peacocks.
Egypt, Fatimid period, 11th - 12th century AD.

Plate O - **Unglazed large jars,** excavated at Ghubayra, Kirman Province, Iran, in 1971. (Photo Géza Fehérvári)

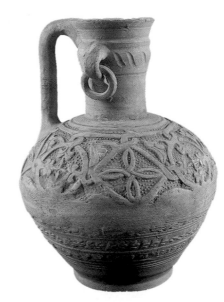

The last object to be discussed here is an unusual and so far unique pottery figurine (**no. 91**). It is the self-portrait of a one armed potter, since his right arm is missing. He is sitting at a potter's wheel, with his right leg pushing the wheel and with his left hand shaping a pot. It was made of composite white fritware, the details were painted in black under a turquoise-blue glaze. As to the possible provenance and date, the peaked capay indicate a Turcoman or Afghan provenance and the date is most likely to be of the early 13th century.

85. **Large jug,** unglazed ware with carved, incised and moulded decoration. *Iran, Khurasan? 12th - 13th century AD.* (Photo Tareq S. Rajab)

98

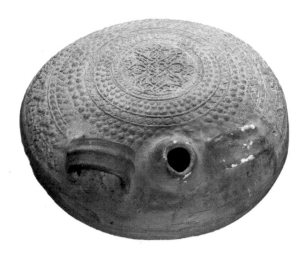

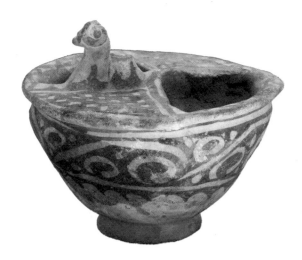

86. Large pilgrim flask, unglazed ware with moulded decoration. *Iran, 12th - 14th century AD.*

87. Container, unglazed, painted ware. *Probably Syria, Mamluk period, 13th - 14th century AD.*

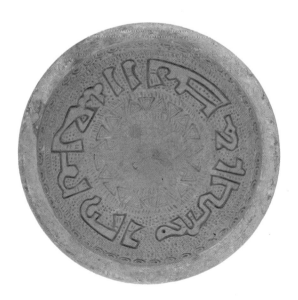

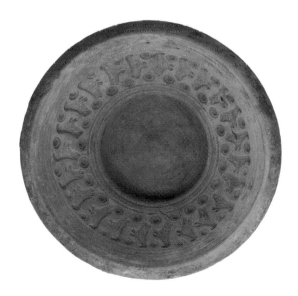

88. Mould, for a lead-glazed relief ware. *Iraq, early Abbasid period, late 8th - early 9th century AD.*

89. Mould, for the internal decoration of a bowl. *Iran, 12th - 13th century AD.*

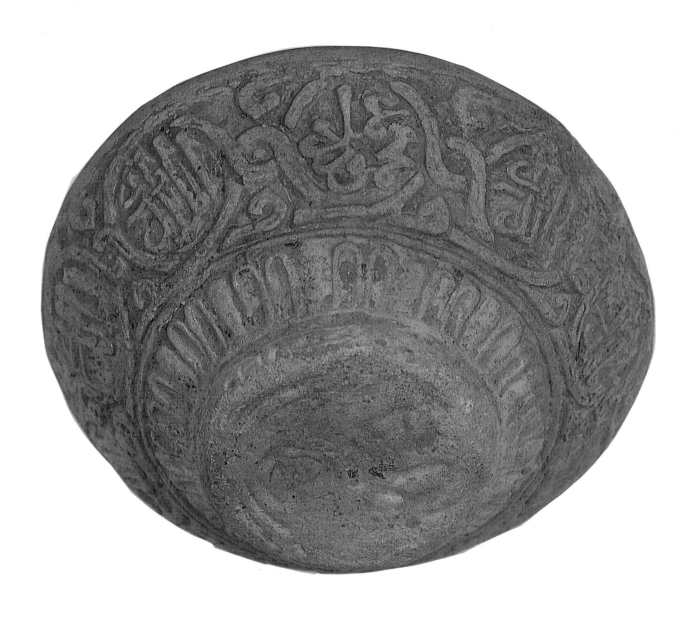

90. Cast, with the artist's signature: *"amala Mahmud"*. This is an extremely rare piece and it may have been intended to be glazed but, for some unknown reasons, the potter was unable to complete his work.
Iran, 12th - 13th century AD. (Photo Tareq S. Rajab)

D.I.T.
LIBRARY
MOUNTJOY SQ.

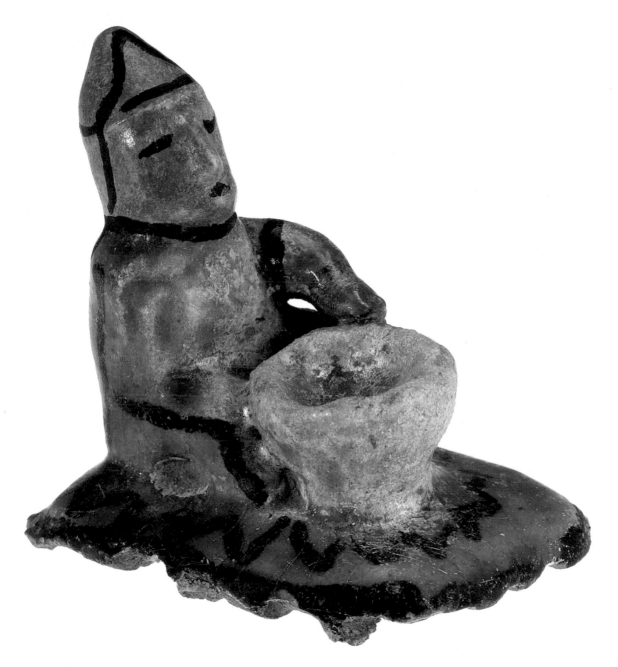

91. Pottery figurine: Self-portrait of a one-armed potter. He is shaping a vessel with his left hand and is pushing the potter's wheel with his right leg.
Probably Afghanistan, early 13th century AD.

101

CATALOGUE OF ISLAMIC POTTERY
IN THE TAREQ RAJAB MUSEUM
REFERRED TO IN THIS BOOK

1. **Large jar**, faience body, covered with a turquoise-blue alkaline glaze, with *applique* decoration.
Iran or Iraq, 7th - 8th century AD.
Height: 41cm; Top Diameter: 19.5cm.
CER-1527-TSR

2. **Pilgrim flask**, monochrome glazed, Umayyad, buff earthenware, coated with a dark green lead glaze and decorated with a solar pattern and rays.
Probably Syria, Umayyad period, 7th - 8th century AD.
Height: 20.5cm; Width: 16.5cm.
CER-10-TSR

3. **Bowl**, lead-glazed relief ware.
Syria or Iraq, late 8th or early 9th century AD.
Height: 7.7cm; Top Diameter: 17.5cm.
CER-1524-TSR

4. **Pottery lamp**, splashed ware.
Iran, late 9th or 10th century AD.
Height: 10.5cm; Top Diameter: 9cm.
CER-903-TSR

5. **Bowl**, opaque-white, or tin-glazed ware, with cobalt-blue decoration. The inscription reads: *"blessing to the owner, made by Ahmad"*.
Iraq, probably Basra, 9th century AD.
Height: 8.8cm; Top Diameter: 24.8cm.
CER-1739-TSR

6. **Bowl**, painted in polychrome lustre.
Iraq or Egypt, late 9th or early 10th century AD. Height: 6.5cm; Top Diameter: 22.5cm. CER-44-TSR

7. **Small bowl**, painted in yellowish-green monochrome lustre, showing the portrait of a dancing lady, holding a goblet in her right hand and a conical object, perhaps a bottle in her left.
Iraq, 10th century AD.
Height: 6cm; Top Diameter: 17cm.
CER-1525-TSR

8. **Bowl**, slip-painted, Nishapur polychrome ware, showing a seated female figure approached by two angels.
Iran, Nishapure, 10th century AD.
Height: 7cm; Top Diameter: 23cm.
CER-57-TSR

9. **Large bowl**, slip-painted, black-on-white ware, decorated with an inscription, beautifully written in floriated and plaited Kufic.
Iran, Nishapur, 10th century AD.
Height: 10cm; Top Diameter: 33.5cm.
CER-1528-TSR

10. **Large bowl**, slip-painted, polychrome-on-white ware, the simple Kufic inscription is a quotation from the Qur'an *Surat al-Qalam*, verses 51-52, reading: *"...and the Unbelievers would almost trip Thee up with their eyes when they hear the Message; and they say: "Surely he is possessed. But it is nothing less than the Message to all the worlds."*
Uzbekistan,Samarqand,dated: 300AH/ AD912.
Height: 11cm; Top Diameter: 35cm.
CER-582-TSR

11. **Large bowl**, slip-painted, yellow-staining-black ware. It is decorated with floriated pseudo-Kufic

inscriptions running all around the cavetto; one is facing outward, the other inward. The word across the base reads: "Ahmad", "may he do that which is worth praisy".
Iran, probably Nishapur, 10th century AD.
Height: 12cm; Top Diameter: 34cm.
CER-130-TSR

12. **Bowl**, made of buff earthenware, showing incised floral decoration under the transparent cobalt-blue glaze. It was fired on its side and therefore the glaze collected in a pool on one side of the base.
Egypt, Fatimid period, 12th century AD.
Height: 8cm; Top Diameter: 19cm.
CER-1780-TSR

13. **Large jar**, buff earthenware, covered with a green glaze and painted with lustre, signed: *"amalahu Baytar"*, *"made by Baytar"*.
Egypt, Fatimid period, late 10th - early 11th century AD.
Height: 30.5cm; Top Diameter: 10cm.
CER-1760-TSR

14. **Bowl**, decorated with yellowish-green lustre, showing a lion in the centre; the foliated inscription on the rim reads: *"baraka l-sahibihi"* (twice), *"blessing to the owner"* , then *"tawakkul tukfa"* *"trust in God"* and *"sal tu'ta"*, *"ask (God) and you will be given"*.
Egypt, late 10th - early 11th century AD.
Height: 5.5cm; Top Diameter: 23.5cm.
CER-181-TSR

15. **Bowl**, red earthenware, inside coated with a thin ground yellow slip then painted in green and manganese under a clear lead glaze.
North Africa, probably Tunisia, 11th - 12th century AD. Height: 9cm; Top Diameter: 20.7cm. CER-916-TSR

16. **Bowl**, red earthenware, coated with a yellow slip and decorated with incised floral designs under the colourless lead glaze.
Iran, 12th century AD.
Height: 9cm; Top Diameter: 19.7cm.
CER-1743-TSR

17. **Small Bowl**, "Amol" ware, red earthenware, with incised and green painted decoration under a colourless glaze.
Iran, Mazandaran, 12th century AD.
Height: 5cm; Top Diameter: 13.5cm.
CER-160-TSR

18. **Bowl**, *champleve* or carved ware, showing a seated figure, probably a ruler or a prince. The decoration was carved out of a black slip, then the entire vessel was coated with a transparent green lead glaze.
Iran, Garrus district, 12th century AD.
Height: 9.5cm; Top Diameter: 20.5cm.
CER-1746-TSR

19. **Large bowl**, Aghkand ware, with a cockerel against a floral scroll ground, painted in green, yellow and manganese.
Iran, Aghkand district, 12th century AD.
Height: 9cm; Top Diameter: 29.5cm.
CER-1747-TSR

20. **Deep pedestal** or **"Bamiyan" bowl**, buff earthenware, coated with a creamy ground slip into which the sgraffiato designs were incised and splashed with green and manganese.
Afghanistan, Bamiyan, 12th - early 13th century AD.
Height: 6.5cm; Top Diameter: 19.3cm.
CER-929-TSR

21. **Large dish**, red earthenware, coated with a ground yellow slip into which the decoration was

incised, then splashed with green and manganese.
Afghanistan, probably Bamiyan, 12th - 13th century AD.
Height: 7cm; Top diameter: 38.5cm.
CER-911-TSR

22. **Jug**, Seljuq white ware, with moulded, pierced and cobalt-blue painted decoration, showing animals, including a dragon.
Iran, probably Kashan, 12th - early 13th century AD.
Height: 16cm; Top Diameter: 7.7cm
CER-1583-TSR

23. **Incense-burner**, monochrome glazed ware.
Iran, probably Kashan, 12th - early 13th century AD.
Height: 18cm; Top Diameter: 10cm.
CER-291-TSR

24. **Jug**, silhouette ware, showing running animals.
Iran, 12th century AD.
Height: 13.5cm; Top Diameter: 8cm.
CER-218-TSR

25. **Bowl**, painted in black and cobalt-blue under clear glaze. Iran, Kashan, 13th century AD.
Height: 9.5cm; Top Diameter: 22.5cm.
CER-402-TSR

26. **Lid**, with painted decoration under turquoise-blue glaze. The small seated figure serves as a handle.
Iran, 13th century AD.
Height: 7cm; Top Diameter: 9cm.
CER-390-TSR

27. **Large tray**, lustre painted showing an enthroned monarch or prince, with his courtiers and attendants.

Iran, Kashan, early 13th century AD.
Height: 4.2cm; Top Diameter: 39cm.
CER-669-TSR

28. **Large dish**, painted in lustre and overglaze red, with two splashes of cobalt-blue.
Iran, probably Kashan, early 13th century AD.
Height: 7.5cm; Top Diameter: 35.5cm.
CER-1926-TSR

29. **Bowl**, overglaze-painted, so-called *mina'i* ware, depicting two horsemen meeting at a small pond under a tree.
Iran, probably Kashan, late 12th or early 13th century AD.
Height: 8cm; Top Diameter: 18.5cm.
CER-456-TSR

30. **Small bowl**, so-called "Seljuq white" ware, wth moulded, and pierced decoration, with splashes of manganese and cobalt-blue.
Afghanistan, 12th - early 13th century AD.
Height: 8cm; Top Diameter: 17cm.
CER-1757-TSR

31. **Small dish**, coated with a turquoise-blue glaze, showing an intricate moulded design.
Afghanistan, 12th - early 13th century AD.
Height: 4cm; Top Diameter: 16cm.
CER-232-TSR

32. ***Mihrab* tile**, rectangular, covered with a green glaze.
Iran or Afghanistan, 12th - early 13th century AD.
29 x 22cm.
CER-1982-TSR

33. **Jug**, *laqabi* ware, buff earthenware, with a moulded epigraphic band of a benedictory

inscription, reading: *"Glory, prosperity, power, good fortune and honour"*.
Syria, 12th century AD.
Height: 18.5cm; Top Diameter: 9cm.
CER-657-TSR

34. **Hexagonal table**, monochrome glazed ware, with extensive moulded, incised and openwork decoration.
Syria, first half of the 13th century AD.
Height: 26cm; Top Diameter: 28cm.
CER-1066-TSR

35. **Large bird**, coated with a turquoise-blue glaze and painted in black under the glaze painted.
Syria, probably Raqqa, late 12th - early 13th century AD.
Height: 32cm.
CER-494-TSR

36. **Bowl**, painted in polychrome under a clear glaze. The inscriptions are typically Mamluk, reading: *"Glory to our Lord, the / King, helped by Heaven / the Sultan..."*
Syria, probably Damascus, Mamluk period, 14th - 15th century AD.
Height: 11.5cm; Top Diameter: 22cm.
CER-589-TSR

37. **Panel of nine Damascus tiles**, hexagonal tiles, painted in black and blue, some also in turquoise.
Syria, probably Damascus, Mamluk period, 15th century AD.
Measuring 17cm between the parallel lines.
CER-1728-TSR

38. **Large jar**, with moulded and chocolate-brown lustre painted decoration with some cobalt-blue and turquoise colours.

Syria, Raqqa, 13th century AD. Height: 33.5cm; Top Diameter: 13.3cm.
CER-501-TSR

39. **Chamber pot**, painted in chocolate-brown lustre and cobalt-blue. Such vessels were very popular in Syria and large number of these were found in excavations.
Syria, Raqqa, 13th century AD.
Height: 13cm; Top Diameter: 16cm.
CER-502-TSR

40. **Dish**, blue and white ware.
Syria, Mamluk period, late 14th - early 15th century AD.
Height: 6cm; Top Diameter: 23.5cm.
CER-593-TSR

41. **Jar**, blue and white ware.
Syria, Mamluk period, 15th century AD.
Height: 26.5cm; Top Diameter: 12cm.
CER-594-TSR

42. **Bowl**, *sgraffiato* ware, with incised decoration and painted in yellow, green and manganese.
Syria, 12th century AD.
Height: 8cm; Top Diameter: 24.5cm.
CER-655-TSR

43. **Cup bowl**, simple *sgraffiato*, coated with a green glaze.
Egypt, Mamluk period, late 13th - early 14th century AD. Height: 14cm; Top Diameter: 13.5cm. CER-605-TSR

44. **Bowl**, Mamluk *sgraffiato* with a hexagonal star and four swimming fish around and pseudo-Kufic inscription on the rim.
Egypt, Mamluk period, 14th century AD.
Height: 10cm; Top Diameter: 26.5cm.
CER-615-TSR

45. **Bowl**, Mamluk *sgraffiato*, with Mamluk *naskh* inscription.
Syria, Mamluk period, 14th - 15th century AD.
Height: 9.5cm; Top Diameter: 19.2cm.
CER-617-TSR

46. **Rectangular tile**, monochrome glazed.
Iran, Ilkhanid period, dated: 684AH/AD1285.
30 x 20.5cm.
CER-1751-TSR

47A-B. **Large bowl**, underglaze-painted, so-called "Sultanabad" ware.
Iran, probably Arak region, Ilkhanid period, dated 716AH/ AD1316.
Height: 14.5cm; Top Diameter: 33cm.
CER-563-TSR

48. **Bowl**, underglaze-painted, so-called "Sultanabad" ware.
Iran, probably Arak region, Ilkhanid period, 13th - early 14th century AD.
Height: 8.7cm; Top Diameter: 20.5cm.
CER-1768-TSR

49. **Large bowl**, underglaze-painted ware.
Iran, probably Kashan or Kirman Province, Ilkhanid period, late 13th - early 14th century AD.
Height: 13cm; Top Diameter: 26cm.
CER-1767-TSR

50. **Bowl**, lustre and cobalt-blue painted.
Iran, probably Kashan, Ilkhanid period, 13th - early 14th century AD.
Height: 10.5cm; Top Diameter: 15cm.
CER-446-TSR

51. **Large bowl**, overglaze-painted, transitional *mina'i - lajvardina* ware. Moulded, gilt and painted in black and white over a light blue glaze.
Iran, Kashan, Ilkhanid period, mid-13th century AD.
Height: 9cm; Top Diameter: 31.2cm.
CER-1531-TSR

52. **Tile**, overglaze-painted, so-called *lajvardina* ware.
Iran, Ilkhanid period, 13th - early 14th century AD.
34 x 32 x 3cm.
CER-464-TSR

53. **Bowl**, underglaze painted ware.
Iran, Timurid period, late 14th - early 15th century AD.
Height: 9.5cm; Top Diameter: 19.7cm.
CER-1111-TSR

54. **Bowl**, underglaze painted ware.
Iran, Timurid period, late 14th - early 15th century AD.
Height: 9cm; Top Diameter: 20.5cm.
CER-1119-TSR

55. **Jar**, blue and white ware.
Iran, Timurid period, late 15th century AD.
Height: 16cm; Top Diameter: 10cm.
CER-748-TSR

56. **Large bowl**, so-called "Hispano-Moresque" ware, painted in lustre and cobalt-blue.
Spain, Malaga, ca. 1400AD.
Height: 14cm; Top diameter: 43cm.
CER-703-TSR

57. ***Albarello***, so-called "Hispano-Moresque" ware, painted in lustre and cobalt-blue.
Spain, late 15th or early 16th century AD.
Height: 30cm; Top Diameter: 10.5cm.
CER-704-TSR

58. **Inkwell**, in the shape of a four-petalled flower, with openwork decoration, coated with a dark cobalt-blue glaze.
Morocco, 18th - 19th century AD.
Height: 6.3cm; Top Diameter: 21.5cm.
CER-770-TSR

59. **Large dish**, painted in black, blue and green over a yellow ground slip.
Morocco, probably Fes, early 19th century AD.
Height: 10cm; Top Diameter: 34.5cm.
CER-1465-TSR

60. **Ewer**, painted in green, blue, yellow and black.
Morocco, probably Fes, early 19th century AD.
Height: 33cm.
CER-1515-TSR

61. **Large dish**, painted in polychrome with floral and geometrical patterns.
Morocco, second half of the 19th century AD.
Height: 9cm; Top Diameter: 29cm.
CER-1770-TSR

62. **Large dish**, so-called "Kubachi" ware, painted in black under a blue glaze.
Iran, Safavid period, late 16th century AD.
Height: 6cm; Top Diameter: 33.5cm.
CER-627-TSR

63. **Large dish**, so-called "Kubachi" ware, painted in indigo blue under a clear glaze.
Iran, Safavid period, early 16th century AD.
Height: 7cm; Top Diameter: 33.5cm.
CER-628-TSR

64. **Small dish**, so-called "Kubachi" ware, painted in polychrome under a clear glaze.
Iran, Safavid period, early 17th century AD.
Height: 4cm; Top Diameter: 20cm.
CER-629-TSR

65. **Large dish**, celadon imitation.
Iran, probably Kirman, Safavid period, 17th century AD.
Height: 7.5cm; Top Diameter: 31cm.
CER-586-TSR

66. **Large bowl**, blue and white ware.
Iran, Meshhed, Safavid period, 17th century AD.
Height: 15.5cm; Top Diameter: 36cm.
CER-765-TSr

67. **Spitoon**, blue and white ware.
Iran, Meshhed, early 17th century AD.
Height: 13cm; Top Diameter: 5cm.
CER-1126-TSr

68. **Dish**, so-called "Kirman polychrome" ware.
Iran, Kirman, Safavid period, 17th century AD.
Height: 4cm; Top Diameter: 25.8cm.
CER-643-TSR

69. **Ewer**, painted in lustre over cobalt-blue glaze.
Iran, Safavid period, late 17th or early 18th century AD.
Height: 19cm; Top Diameter: 11cm.
CER-700-TSR

70. **Bowl**, so-called "Gombroon" ware with openwork decoration.
Iran, Safavid period, late 17th - early 18th century AD.
Height: 8.8cm; Top Diameter: 20cm.
CER-701-TSR

71. **Kalian**, polychrome painted ware.
Iran, Qajar period, 19th century AD.
Height: 22.5cm; Top Diameter: 3.5cm.
CER-1776-TSR

72. **Mihrab** tile, polychrome painted. Signed: Made in the workshop of Master Agha Khan in Darwazeh Daulet" (a district of Tehran). Iran, Qajar period, 19th century AD. 69 x 51.5cm. CER-1729-TSR

73. **Panel of nine tiles**, painted in polychrome with hatay motifs and saz leaves. Turkey, Iznik, second half of the 16th century AD. 94 x 94cm. CER-1731-TSR

74. **Dish**, painted in polychrome. Turkey, Iznik, ca. 1560 - 75. Height: 6cm; Top Diameter: 30.5cm. CER-711-TSR

75. **Large dish**, painted in blue, black and green. Turkey, Iznik, ca. 1570 - 80. Height: 7cm; Top Diameter: 30cm. CER-708-TSR

76. **Tankard**, painted in polychrome. Turkey, Iznik, ca. 1580 - 90. Height: 15.5cm; Top Diameter: 7.5cm. CER-718-TSR

77. **Rose-water sprinkler**, with silver mount, painted in polychrome. Turkey, Kutahya, 18th century AD. Height: 27cm; Base Diameter: 5.5cm. CER-738-TSR

78. **Pilgrim flask**, painted in polychrome. Turkey, Kutahya, 18th century AD. Height: 24cm; Top Diameter: 3cm CER-752-TSR

79. **Hanging ornament**, painted in polychrome. Turkey, Kutahya, 18th century AD.

Height: 20.5cm; Diameter in the centure: 19cm. CER-1730-TSR

80. **Jar**, red earthenware with moulded and appliqué decoration. Iran, Sasano - Islamic, 6th - 8th century AD. Height: 16.5cm; Top Diameter: 7cm CER-1377-TSR

81. **Jug**, unglazed, painted ware. Syria, Umayyad period, 7th - 8th century AD. Height: 17cm; Top Diameter: 8.5cm. CER-1204-TSR

82. **Pottery-lamp**, moulded, unglazed ware. Syria, Umayyad period, 7th - 8th century AD. Height: 4cm; Length: 9.5cm. CER-24-TSR

83. **Ewer**, unglazed, painted. Central Asia, 10th - 12th century AD. Height: 27.5cm; Top Diameter: 6.5cm. CER-1211-TSR

84. **Bottle**, unglazed ware with carved and moulded decoration, showing peacocks. Egypt, Fatimid period, 11th - 12th century AD. Height: 18cm; Bottom Diameter: 6cm. CER-1790-TSR

85. **Large jug**, unglazed ware with carvd, incised and moulded decoration. Iran, Khurasan? 12th - 13th century AD. Height: 34cm; Top Diameter: 9.5cm. CER-1858-TSR

86. **Large pilgrim flask**, unglazed ware with moulded decoration. Iran, 12th - 14th century AD. Height: 21cm; Top Diameter: 3.5cm. CER-1316-TSR

87. Container, unglazed, painted ware.
Probably Syria, Mamluk period, 13th - 14th century AD.
Height: 12.5cm; Top Diameter: 15cm.
CER-1208-TSR

88. Mould, for a lead-glazed relief ware.
Iraq, early Abbasid period, late 8th - early 9th century AD.
Height: 7cm; Top Diameter: 19cm.
CER-1604-TSR

89. Mould, for the internal decoration of a bowl.
Iran, 12th - 13th century AD.
Height: 8.5cm; Top Diameter: 17cm.
CER-335-TSR

90. Cast, with the artist's signature: *"amala Mahmud"*.
Iran, 12th - 13th century AD.
Height: 6.8cm; Top Diameter: 16cm.
CER-1778-TSR

91. Pottery figurine: Self-portrait of a potter.
Probably Afghanistan, early 13th cneuty AD.
Height: 7cm.
CER-672-TSR

ADDITIONAL PLATES

Plate A The small, little known, **Dome of the Chain** located outside the entrance to the Dome of the Rock in Jerusalem. The tile work was ordered by Sultan Sulaiman the Magnificent - 969AH/AD1561.

Plate B The inside of the **Dome of the Chain** completely covered with ceramic tiles - 969AH/AD1561.

Plate C **The spiral minaret of the great mosque in Samarra,** the capital of the Abbasid for a short period, begun by the Caliph al-Mutawakkil in 233AH/AD847. The mosque is the greatest in the Islamic world.

Plate D **The mihrab in the mosque of Ibn Tulun, Cairo,** ordered by the Fatimid Caliph al-Mustansir Billah - 487AH/AD1094.

Plate E **Remains of an early Islamic Pottery kiln.** Excavated at Bahnasa/Oxyrhynchus by the Archaeological team from Kuwait in 1987.

Plates F and G **Two Fragments of polychrome in-glaze painted ware.** Excavated at Medinet Sultan, *(al-Qadima)* in Libya, in 1978.

Plate H **Remains of two pottery kilns at Gurgan (Jurjan).** Excavated by Dr. Muhammad Yousef Kiani, in 1974.

Plate I *Mihrab* **or Prayer-niche recess in the Masjid-i-Ali in Qohrud, Central Iran.** The walls are decorated with monochrome glazed and lustre-painted tiles.

Plates J and K **Views of Abaqa Khan's palace at Takht-e-Sulayman in North-western Iran.** The palace is situated behind the lake.

Plate L **Yezd,** the faience tiled mihrab of the great mosque (Masjid-i Jami) completed in 777AH/AD1375.

Plate M **View of the Qal'a-e Dukhtar in Kirman, Iran,** where large number of Chinese celadon and blue and white porcelain and their local imitations were collected.

Plate N **The Mausoleum of Sultan Eyüp in Istanbul.** Built soon after the conquest of Constantinople in 1458, at the order of Sultan Mehmet II, the Conqueror. The walls of the mausoleum were decorated during the 16th century with Iznik tiles.

Plate O **Unglazed large jars,** excavated at Ghubayra, Kirman Province, Iran, in 1971.

SUGGESTED FURTHER READING

Altun, A., Carswell, J. and Oney, G. *Turkish Tiles and Ceramics, Istanbul, 1991.*

Atasoy, N., Raby, J. *IZNIK. The Pottery of Ottoman Turkey, London 1989.*

Atil, Atil *Ceramics from the World of Islam, Washington, 1973.*

Bahrami, M. *Gurgan Faiences, Cairo, 1949.*

Caiger-Smith, A. *Tin-Glaze Pottery in Europe and the Islamic World, London, 1973.*

Caiger-Smith, A. *Lustre Pottery. Technique, Tradition and Innovation in Islam and the Western World, London, 1985.*

Carswell, J. and Dowsett, C.J.F. *Kütahya Tiles and Pottery from the Armenian Cathedral of St. James, Jerusalem, Oxford, 1972, 2 vols.*

Fehérvári, G. *"III. The Lands of Islam", in World Ceramics, edited by R.J. Charleston, London, 1st ed. 1968, pp.69-98.*

Fehérvári, G. *Islamic Pottery. A Comprehensive Study based on the Barlow Collection, London, 1973.*

Fehérvári, G. *La Ceramica Islamica, Milano, 1985.*

Grube, E. J. *Islamic Pottery of the Eighth to the Fifteenth Century in the Keir Collection, London, 1976.*

Grube, E. J. *Cobalt and Lustre. The Nasser D. Khalili Collection of Islamic Art, vol. IX, Oxford, 1995.*

Lane, A. *Early Islamic Pottery, London, 1947.*

Lane, A. *Later Islamic Pottery, London, 1957.*
2nd edition 1971.

Öney, G. *Turkish Ceramic Tile Art, Tokyo, 1975.*

Öney, G. *Türk Çini Sanati. Turkish Tile Art, Istanbul, 1976.*

Philon, H.	*Early Islamic Ceramics. Benaki Museum, Athens, London, 1980.*
Porter, V.	*Medieval Syrian Pottery, Oxford, 1981.*
Porter, V. and Watson, O.	*"Tell Minis Wares", in Syria and Iran. Three Studies in Medieval Ceramics, Oxford, Studies in Islamic Art, IV, ed. by J. W. Allan and C. Roberts, Oxford, 1987, pp. 175-248.*
Porter, V.	*Islamic Tiles, British Museum, London, 1995.*
Soustiel, J.	*La Céramique Islamique, Fribourg, 1985.*
Watson, O.	*Persian Lustre Ware, London, 1985.*
Wilkinson, C. K.	*Nishapur: Pottery of the Early Islamic Period, New York, 1973.*